VISIONS

with an introduction by Walter Hopps

Curator 20th Century American Art,

National Collection of Fine Arts, Smithsonian Institution

an original book publication by Pomegranate Publications

VISIONS, VOLUME I

Library of Congress catalog no. 76-24519

ISBN 0-917556-00-3

DISTRIBUTED IN THE UNITED KINGDOM BY:

Big O Publishing Ltd.
219 Eversleigh Road
London SW 11 5UY

Notecard and large poster size reproductions of many of the plates in this book are available. For information and free catalog write Pomegranate Publications, P.O. Box 748, Corte Madera, California 94925. Dealer inquiries are invited. In the U.K. write to Big O Publishing.

Drawing Credits: opposite, Bill Martin; page VI, Nick Hyde; page VIII, Gage Taylor; page IX, Cliff McReynolds; page X left, Bill Martin, right, Cliff McReynolds; page XI, Sheila Rose; page XIII, Gage Taylor; page XV, Gage Taylor.

Plate no. 2 courtesy of Paul Hoffman; plate no. 5 courtesy of Sarah Estribou; plates no. 8, no. 9 and no. 37 courtesy of Gregory Vlamis.

Front Cover:
HOLY GROVE,
by Gage Taylor
1975 oil on canvas
42″ diameter

Back Cover:
A NEW EARTH (II PETER 3:13),
by Cliff McReynolds
1976 oil on canvas
40″ x 40″

PRINTED IN THE UNITED STATES OF AMERICA by Regensteiner Press

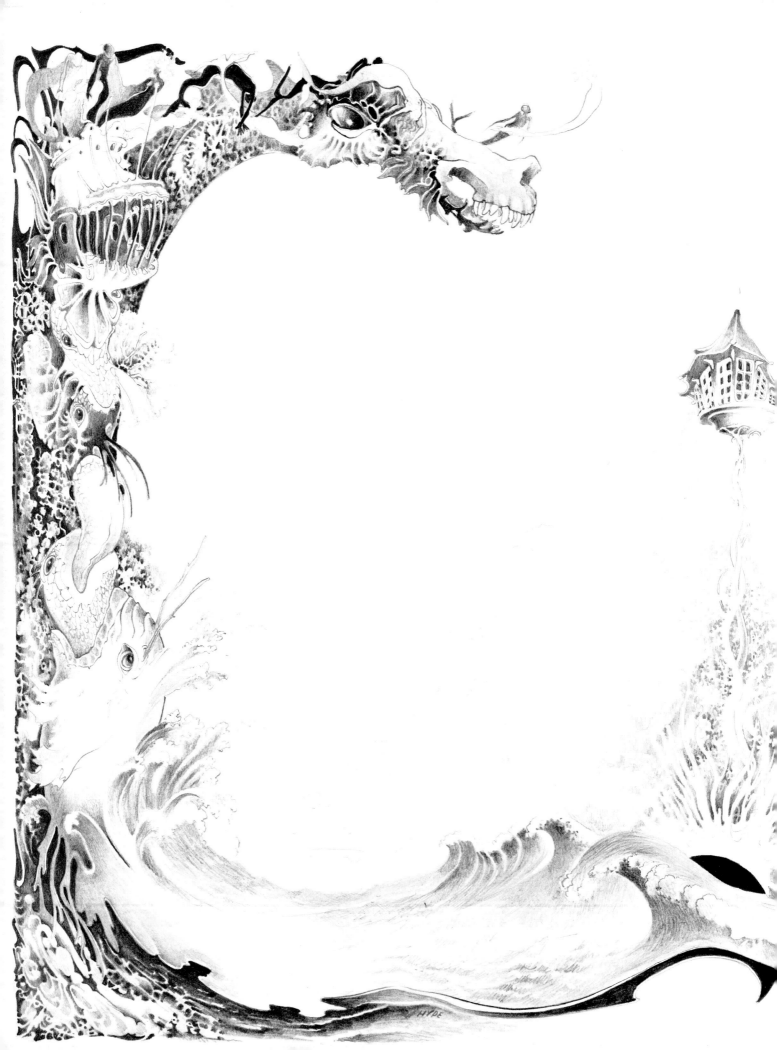

Imagine a time, and a place: standing at a street corner near the San Francisco Panhandle in 1965, trying to decipher a rock concert poster, whose information threads and twists through such elaborate designs that considerable time and concentration is required to finally decode it, to dislodge the message embedded in its ornamentation. These new poster graphics are quite the reverse of the typical promotional advertisement: they're altogether impossible to read at a glance, from a passing car window, or while paging through the entertainment section. The brand name is almost incidental to the intricate beauty of its becoming.

These posters demand prolonged study, they demand that you stop and devote your undivided attention to their discovery; time slows to a meditational pace while you re-learn the alphabet and re-string the words, which eventually emerge as well-known realities — Grateful Dead, Avalon Ballroom — but now somehow enriched, by virtue of the effort and challenge re-invested in the normally semi-conscious act of reading, now strongly experienced as seeing.

A time, and a place: 1969, the San Francisco Art Institute: seeing a work-in-progress by a young art student named Nick Hyde — the work that was to become *Estate of Man* (Plate 36). A year later, while selecting the paintings for showing in the San Francisco Art Institute Centennial Exhibition, with the painter Richard Diebenkorn, he and I were struck by two works: Bill Martin's extraordinary convex canvas *Crater* (Plate 11), and Gage Taylor's *The Road* (Plate 13). This occasion, virtually the last of the huge juried shows across the United States, gave me a first glimmer of a new kind of painting, painstakingly rendered and prophetically revealing.

I was seeing the germinal work of young, profoundly serious, and as yet unknown artists. From the splintering light and explosive possibilities of the counter-culture that flourished in San Francisco during the late 60's, they were emerging with their spirits and energies intact, now at a moment when that culture appeared to have already peaked and passed its high point. As the dream of those years seemed to be fading from those of us who had believed in it and watched it with admiration, some came forth who had been a part of it, and lived it, assimilating its philosophies and its forms, coalescing that experience into a concrete vision.

I was seeing a kind of art evolving out of a way of life, an art totally apart from the mainstream of the modernist art theory and practice, in which so many of us have been schooled. I was seeing contemporary art not so much immersed in itself as art, as engaged in an ongoing dialogue with life, accessible by virtue of its shared humanity, rather than by an academic indoctrination.

"Art is an attitude toward life. If you aim your work and your life high, keep your scene harmonious, then you are an artist, and your life is art."
— Gage Taylor, 1971

Imagine a timeless place: suspended before a brilliant, bulging world bathed in spellbinding silence, where matter and energy fuse in compelling clarity and monumental mystery. An unnerving sense of revelation streams forth from every surface, as if a film of familiarity were peeled away from the eye itself, unblinking and impaled. Not a dream, not a mirror, but a vision in the most ocular sense of the word: a world sensationally *seen,* possessing its own teeming, overwhelming mind, which grips the viewer in its serene stare, gazing back with the cosmic calm of a third eye, radiating knowledge of vast spheres manifest in every minute leaf and ripple.

"We may be joined in our imaginations by a timeless cosmic connection."
— Sheila Rose, 1976

This world is our own, but now incredibly visible — atmospheric distortions vanish, and distances rush forward with the speed of light. Or is it I myself who rush forward, irresistibly drawn to the spiritual center of this magnetic world, falling upwards toward the still focus of eternity, where each object is the shore of a fathomless ocean of light, and of utter implication...

"I'd like to re-arrange the world, and I will."
— Bill Martin, 1971

Imagine a time: the present, and a place: the Sun Belt, that arc of geography crossing the Southern United States, from the Bay Area to Southern California, across the Southwest, the Southeast, and up the East Coast as far north as Washington, D.C. Since the late 1960's what had been appearing as sporadic flashes of new visions, began increasingly to cohere into constellations of activity. California has been the nucleus of this activity; seven extraordinary artists have most acutely defined it: Thomas Akawie, Nick Hyde, Bill Martin, Cliff McReynolds, Joseph Parker, Sheila Rose, Gage Taylor. They have stayed near nature, observing minutely the earth and the sky, and exploring metaphysically their respective inner worlds. Throughout the 1970's their art has developed and matured, and been shared among one another.

It was in and around San Francisco at the beginning of this decade that the first public presence of new visionary art was felt. There came a moment when within the Sixties poster explosion — all the psychedelia, social dialectic, rock dance announcement, and proclaimed demonology, from the delightfully inventive to the trashy and trite — one began to see examples of something very different indeed: a large fine reproduction of a painting by Parker, a painting by Martin, a painting by Taylor, turning up with all the widespread distribution of any poster on the street. The extraordinary thing that was occurring was that these artists, and subsequently others, consciously decided to communicate the substance of their art to an un-preselected audience, and to subvert a dependence upon the traditional gallery network. Royalties from the mass sale of low cost, high quality reproductions of their paintings became a guaranteed survival income. The success of this approach has allowed artists such as these seven to maintain possession of their cherished works and to exercise an unusual degree of control and discrimination when they part with them for exhibition or sale.

What is important is that the original painting is not *necessarily* sold, subject to the fluctuating tastes of an elite group of dealers, collectors, and critics. These artists are in one sense their own enormous audience; yet this should not discount the energy of their evangelical commitment to enlighten, soothe and bring joy to the widest possible audience. They are making art, not for the self-perpetuating few, but for the larger human community.

"Showing my work is important to me because my art is how I choose to communicate. I want as many people to see my art as possible. That's what's good about having your art reproduced on a mass scale. It loses its preciousness, hence its expensiveness, and becomes available to anyone. If I never showed my work, I would probably lose interest in making it."
— Gage Taylor, 1971

These seven artists have come to show their works both individually and variously in conjunction, in group shows at museums and galleries. One of the earliest occasions was the exhibition, *Beyond the Actual — Contemporary California Realist Painting*, organized by Donald Brewer in 1970 for the Pioneer Museum and Haggin Galleries in Stockton, California. Paintings by Martin and Taylor first carried the new vision in a show dominated by California's photorealist painters.

In 1971 some of the new visionaries were first exhibited and reviewed as a collective manifestation. The exhibition, *Visions of Elsewhere* was presented at the San Francisco Art Institute, and Donald Brewer produced the exhibition and catalogue *Other Landscapes and Shadow Land* at the University of Southern California Art Galleries in Los Angeles. This important exhibition included among the work by ten Bay Area visionary artists, paintings by Martin, Taylor, Akawie, Rose and Hyde. Perhaps the first serious review of the new visionaries was written by Thomas Albright that year for the September 2 issue of *Rolling Stone*.

During the past five years the work of these seven artists has begun to appear variously in major exhibitions across the country — the San Francisco Museum of Modern Art, the Art Institute of Chicago, the Smithsonian Institution in Washington, D.C., and the Whitney Museum of American Art in New York. In 1975 a number of the new American visionary artists were first seen in Europe. Martin and Taylor were included in the major international exhibition, *Ninth Paris Biennial*. They were also included along with Sheila Rose in *Mindscapes from the New Land*, organized by Nina Felshin for the Paris Centre Culturel Americain, an exhibition subsequently touring other European cities.

"This art does not have a particularly urban character; it is notoriously absent, at least in a clearly defined way, from cities of a high demographic density like New York and Chicago. But is has nevertheless made its appearance in cities like Washington and San Francisco, where the artists can dis-associate themselves from urban chaos, where there is space to breathe and to re-immerse themselves in the bosom of nature, to look at the sky... It is, therefore, an art which attaches itself to the less peopled regions of the country. In a word, it is an art which is tied to the land."
— Nina Felshin, 1975
"Mindscapes from the New Land"

Distinctively divorced from the metropolis, from its urbanity and activity, these painters have chosen instead to find their faith in a personal, contemplative apprehension of nature, and nature has become, for them, the touchstone of the marvelous, and, in its ontological mysteries, the wellspring of the imagination.

Bill Martin and Gage Taylor perhaps come the closest in their direct response to the natural landscape. In *Garden of Life* (Plate 2) and in *Crater* (Plate 11), Martin paints a lush and primordial paradise regained. What we have in the *Garden of Life* is nature, not so much as it occurs in a given ecological locality, but rather in all of its encyclopedic possibility — an array of flora and fauna that coheres, not so much by enumeration, but by an overall compositional density. Instead of a whole composed of relational parts, as in the classical approach to landscape, one sees a totality of field where color and pattern create a single vibratory unit.

Gage Taylor's natural landscapes mix a Californian's faith with a very Texan sense of whimsy. Curious incongruities of unlikely phenomena abide serenely here, at once idiosyncratic and utterly at home. Like the minute loving couples in Martin's *Crater*, Taylor testifies to the spiritual regeneration discovered by man in nature; his backpackers in *Encounter* (Plate 19), and the meditators in *Aquaria* (Plate 26) and *South Aquaria* (Plate 32) are direct statements of this faith.

Both Taylor and Martin live in Woodacre, California, just north of San Francisco, among the Redwoods they love so deeply, and which Taylor celebrates in *Holy Grove* (Front cover). His frame of reference here is the eye, an extraordinarily encompassing eye with the depth of field of a fish-eye lens, and its point of view from the ground, gazing upwards and converging in on a vanishing point in the sky. Man, like the trees, is rooted in the earth and tends toward the heavens. It is perhaps the most immediately perceived and directly felt of any of these painters' images of nature. How can we see it, if not as the personal realization of a dream:

"The goal of my art is to soothe and, hopefully, to elevate the viewer. I paint landscapes because unspoiled land is beautiful. Beauty is that which excites the soul."
— Gage Taylor, 1975

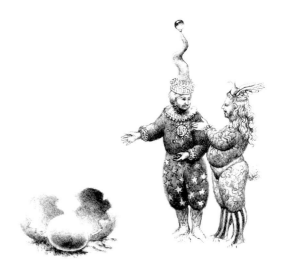

Sheila Rose has migrated from the original California nucleus, and is presently working in the Washington, D.C. area. Her work is the most sheerly scientific of the group, devoted to subject matter of a macro/microcosmic nature, as in her *Cosmic Illusion* (Plate 15), which superimposes a molecular DNA double helix against the spiralling of a galaxy. Rather than presenting a sense of resolved physical manifestations, Rose works to reveal the processes of conception which activate an organic nature.

"The paintings are of those moments of understanding when a great pattern emerges from a chaos of information. It is as if the veil of illusion is lifted, allowing a glimpse of the true nature of the universe. The painting is a celebration of this event. It represents the culmination of one part of the journey and the beginning of another."
Sheila Rose, 1976

To be sure, animal imagery is a vital element in her painting, but it operates in an ideational context, as in *Light* (Plate 1). The flamingos which have come to inhabit her later work are certainly not intended as nature studies — they are emblematic, occult embodiments of mortal life, standing at the intersection of astral life and afterlife: animate, heraldic birds deliberately suggesting the ibis of ancient Egyptian metaphysical iconography. The vivid pink proto-flesh-tones which dominate this later period serve to stress this soul's-eye-view of a continuity unifying all physical elements into one living tissue.

Most consistently Thomas Akawie has been
involved with an occult, suggestively Egyptologi-
cal frame of reference, reproducing ritual poses
and deities, but in a strongly modelled, lumi-
nous state of suspension against the sweeping
skies of the American Southwest. Akawie grew
up in Los Angeles. Recalling the precisionist
fantasy of the spray painted hot rods of Southern
California, he became a master of the spray
technique and a pioneer of its introduction into
the fine arts.

Akawie's restored icons glow with an inner
light, and frequently grow transluscent, as if they
were composed of nothing but light, clothed as
they are in their irridescent, spectrum-refracted
ceremonial garments. And the eyes of his figures
are unexpectedly human, imparting a very
modern impression to the ancient forms from
which they open. His *Osiris* (Plate 5) is particu-
larly striking in its transmutation of the Eye-of-
Horus motif into an enigmatic personification of
God gazing through the cloudy celestial veil.

Akawie is further removed from a Pharaonic
orthodoxy by his incongruous, ecumenical in-
clusion of sinuous Art Noveau decorative motifs
within the frame of his historically derived design,
recollected from his youth among the movie
palaces and exotic architecture of Hollywood.
In general, Akawie's affinity with Egypt is more
vibrational than archaeological, and he explores
this esoteric symbolism as vocabulary, rather
than as personal belief.

Working alone, Cliff McReynolds was un-
known to other visionary artists until relatively
recently. He lives and works in San Diego, in the
southernmost part of California. His landscapes
are lightly or profusely peopled by tiny figures
engaged in tangential encounters and obscure
activities. His compositions range from the most
densely staged, as in *The Arrival* (Plate 40), to
the single intimate encounter, like the small
Landscape with Bird and Boy (Plate 31). A per-
vading sense of a mysterious, almost mythological
feeling for metamorphosis verges on continual
palpable realization throughout his work. He is
attracted above all by opalescent surfaces and
substances in the process of becoming: the
bubble, the pearl, the transluscent wing, figures
half-submerged, or emerging, from tall grass.

Echoing the spirits of the pre-Renaissance
masters, McReynolds feels that his art, like theirs
is essentially addressed to God. The piety of his
purpose vouchsafes of a special realm, a glimpse
of Heaven. In his *Portrait of Heaven* (Plate 24),
the flowering pink and white tree rising above
a pool of clouds and shimmering against a sky
of cobalt blue is like the axis of this "special
realm." It has its counterpart in *A New Earth*
(Back Cover), where a tree resembling the gen-
eral contours of a pastoral paradise on earth,
rises as mysteriously as it morphoses from light
and ether.

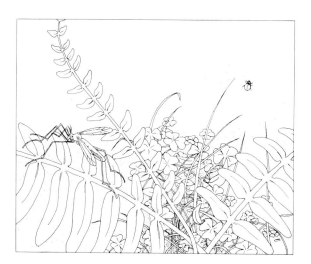

Joseph Parker was the first among these seven painters to attempt to reach a broader spectrum of humanity by the reproduction of his paintings as posters. Yet at the same time he is the most insistently solitary of this group. He is a hermetic figure, having chosen to remove himself from society, to live and paint in virtual isolation in Mexico. His landscapes are unpeopled and temptingly remote, yet radiant with the recaptured moment of spiritual revelation. Unlike the fiery celestial vapors in Akawie's *Ra Rising* (Plate 42) or Rose's extraterrestial nocturnal skies, Parker's burning sunbursts illuminate the exotic verdure and quiet lagoons of what could be a tropical rain forest at the dawn of creation, and the coming of the Godhead. Matter and energy irradiate one another at this perfect moment of primal time.

Parker feels that his work is an announcement and a celebration of a new age, potentially apocalyptic, and imminently Aquarian. Indeed in Parker's paintings the moment's epiphany is invariably solar, introduced on earth from the sky beyond. The burning celestial heart that hovers as some distance above the mountains reflects an "anticipated moment" (Plate 43), *Sunrise in Blue* (Plate 27) projects a more advanced state, in which the sun fans out fantastically over half the composition, mirroring the land and its enclosed lagoon in crystalline perfection.

Perhaps Parker's most interesting work is *The Path* (Plate 51), where implications become explicit. Unlike the meandering path in Taylor's *The Road* (Plate 13), which is so delightfully discursive, Parker's path is as purposeful as a providential angel's arrow. It materializes the kaliedoscopic structures of solar energy. Formed is an inexorable bridge between a present threshold and that which is to come, connecting the circling landscape rim that had formerly kept the viewer at a remove, to the luminous heights of a New Jerusalem.

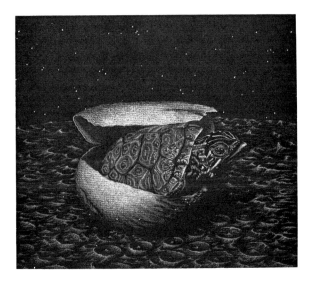

The powerful nature of Nick Hyde's art stands in certain important ways vividly apart from that presented here by his visionary colleagues. Rather than scenes of cosmic calm, serene process, or peaceful resolution, Hyde pours forth effulgent compositions of both hallucinatory intensity and tumultuous activity. The myriad visual events and details brought forth in an all-at-once total vision in Hyde's paintings give rise to a unique tension between what seems the most violent of struggles and the most delicate of dances. In maintaining qualities of such polarity Hyde reveals a mastery of a sinuous, insinuating line structure that both divulges and dissolves images.

In his extraordinary allegorical painting *Estate of Man* (Plate 36), human figures are disgorged from a Gothic tracery of lines that suggests the network of nerves of a livid inner eye. Closer inspection reveals the jaws of a hell-mouth that swallows these figures and assimilates them as functioning fibers in a self-conceiving infernal machine. At upper right, however, in a zone of apparent transcendence, Hyde paints a luminist landscape at the moment of sunrise. It is perhaps where one is to find redemption in the Eye of God: or is it merely the burning earth that bears man to offer him to hell?

Hyde's painting *Abraxas* (Plate 49) touches on a note of subtle, mordant humor: the mythoid monster and his serpent-headed mate entwined in an infernal lair is, at the same time, a gentleman with his lady, reclining at ease, casually smoking, and telephone in hand. A clock — on the fireplace mantle at the right of the composition — is without hands, and ornamented by two barely perceptible figures. They repeat in reverse the pose of the two polymorphic companions. Abraxas, a god of good and evil, exists in a world abandoned of time, of rhythmic mimesis, of smoldering mockery.

With the vistas unfurled by these seven painters we are plunged into an intensely persuasive zone of absolute belief, a belief devoted to re-creating a world in its own introspective image, and to rendering this devotional world

as objectively believable as the natural one from which it derives. Each artist presides over his model universe like an ecstatic god, bestowing it with a wealth of finely detailed contour, texture, and local color, all executed with a consummate, meticulous, precision-tooled craftsmanship, breathtaking in its hyper-real clarity.

These razor-etched visionscapes are even more revealing and convincing than our normal perceptual reality — distant objects are as clearly seen as near ones, airlessly and motionlessly, as though all existed in a completely crystal-clean sublimely immaculate natural shrine, seen through some microtelescopic mental lens, to achieve a degree of astonishing molecular perception which sees further than the actual eye can see.

The group generally works in slow-drying oils, and their finely-tuned works often require years to execute, the final completion dates being somewhat misleading in this regard. Time, for them, is infinitely spacious and expanding, not pressing or constrictive, and the time-consuming painting process is as devotionally significant for them as the finished painting itself. The painter is both all-providing god and abject monk, and his art becomes an increasingly spiritual metaphor for illumination, on consciously lysergic levels: it is its own monastic discipline, the careful, patient progress toward an euphoric enlightenment.

And the viewer is correspondingly drawn into this acute exhilaration of discovery and revelation, as each detail emerges from the ingenious mesh of images. These paintings require a length of time to fully explore — the longer you look, the more you will find to see, and the more deeply you see into the ultimate intention of each atomic epiphany: a kind of propulsive continuity which both urges the eye toward the central vortex, and yet arrests it at every point along the way. There is a definite quality of pilgrimage here, an active sense of dedication repeatedly rewarded.

A striking instance of this is Martin's *Autumn* (Plate 47), with its ever-receding panoply of flora and fauna, or his *Canyon* (Plate 30), where bone and fossil rubble on eroded cliffs and a receding field of clouds resolve in exquisite detail against a lapis sky.

McReynolds can be particularly astounding in this fashion — his work abounds in unique, oblique inventions: the golden fetus-bearing pearl in *New Earth* (Back Cover), the jewel in a bubble perched in a tree in *Landscape with Hand Grenade* (Plate 18), the tiny recurrence in *The Arrival* (Plate 40) of the masked woman with the mirror from *Soon* (Plate 12) — each separate fragment implicitly embodies the whole miracle, populating paradise with a random, innocent individuality.

But, however crucial this consummate craftsmanship may be to the tangibility of their vision, these seven painters are even more fundamentally focused on the whole contemplative overview implicit in the round format and radial organization of the works themselves, toward which all their inner details ultimately tend, and extend: every blade of grass and drop of water testifies unknowingly to the single-minded wholeness hidden by their apparently incidental abundance.

"There is constant joy in the discovery of cosmic unity, from the tiniest particle to the farthest star."
— Sheila Rose, 1976

A key organizational motif, and an abiding motive, of these paintings is the egg and its perceptual twin, the eyeball. Often round or ovoid, these pictures suggest spaces filled with a pristine, transparent fluid, like the aqueous humour of the eye, a suffusing universal fluid which allows aquatic forms to float freely through all the elements as in McReynolds idyllic kingdoms. In Rose's *Stars* (Plate 10) and *Light* (Plate 1), this liquid suspension becomes the gravitationless free-fall of outer space, through which fiery energies ripple eternally, as if in waves across a vast pre-natal ether, containing planets like multiple yolks.

Martin's work could almost function as a manifesto for this eyeball-to-eyeball insistence on the organ of vision — the strong centripetal force of his compositions deliberately emphasizes the sensation of a great eye staring back at the transfixed viewer, an eye which forcibly implies a higher mind at work beyond the zone of vision: the painter's creative eye fused with a cosmic overmind creating the world itself through imaginational vision, an invisible eye which is never quite seen, but the power of its presence is intuited as a perpetual high noon of mystic time.

This subliminal stare is the reason for the inexplicable compelling power Martin's images possess, and is the explanation for their odd, disquieting edge — this naked, eternal eye which never blinks or turns away. His earlier convex canvases heighten this effect, and some of his later eyescapes, such as *Storm* and *The Rock* (Plates 16 and 17) may be likened to the Eye of Jehovah that can command the seas to part, and the rock to bring forth water.

Akawie's *Pyramid Sunset* (Plate 6) transposes two timeless forms — the ocular circle of wholeness, and the focal pyramid of aspiration. Lines of sight reflecting and radiating from the pyramid converge at its apex, just above the horizon and slightly eccentric to the glowing point-nucleus of the sun. This pyramid is an analogue to the image registered by the receptive eye.

Taylor, Rose, and Hyde complement this cosmologically cranial eye with an equally cosmological egg, their ovoid composition enclosing off-center embryonic sunrises and crossroads, and their work is more overtly optimistic and resurrectional. The meditating man in *South Aquaria* (Plate 32) is confidently seated on a yolk-like golden rock, and the left tree-branches in *Aquaria* (Plate 26) strongly suggest a germinating embryo. Even the purgatorial tensions in Nick Hyde's work are contained within their fiercely-swirling ovals, whose motion is somehow analogous to the stately elliptic turning of the galaxy.

The most conscious expression of the mutual inter-significance of egg and eye occurs in Rose's *Egg I* (Plate 28), in which a cracked flamingo egg reveals a galaxy orbiting within, the whole image fusing to form a dispassionate, disembodied blue eye.

This visual preoccupation with the orbic organs of vision and self-contained rebirth is more than a matter of metaphysical content. The paintings themselves are frequently constructed to function as meditational instruments, to lead the mind's eye along with the optic eye toward a new birth of awareness. The frequent appearance of meditating figures in these landscapes is an invitation to re-live the painter's contemplational adventure which resulted in their creation, to see the world in the same holistic light which makes all vision possible. As before a Tantric mandala, the eye is inexorably led toward that dilating point of concentration which is the kernel of cosmic self-recognition, or as in Nick Hyde's *Urp* (Plate 44), where the imagery is overtly Tibetan, toward that fiery vortex which is the gaze of a withering inner eye.

Imagine other times and places: Paris and New York between World War I and II, late Victorian London, the American frontiers of the nineteenth century, the valley of the Danube river in the sixteenth century. Surrealism, the Pre-Raphaelite Brotherhood, the romantically-inspired American landscape of the sublime, the mystical landscape painters of the Danube school.

It has been said that you begin to know yourself when you come to know your ancestors. Artistic visions mature, and find their own coherence, through the gradual recovery and refined resolution of the traditions, symbologies, and preoccupations of the past.

Within the history of contemporary art, it is particularly Surrealism to which these seven painters most significantly relate, in terms of both technique and subject matter. The Surrealists probed the whole spectrum of counter-rational mental states—dream, memory, hallucination, hypnosis, delerium, fantasy—which they believed to be higher, more integrating levels of awareness. Their technique, a precise and systematic recording of the ineffable, sought to impress and render substantial their vivid interior visions, in an attempt to be as optically convincing as photography itself.

There are clear affinities between the symbolic landscapes of Dali, De Chirico, Ernst, Magritte, and Tanguy, and the para-physical paintings of these seven artists from California. The deserted plazas and desert apparitions of De Chirico and Dali are genetically related to the enigmatic expanses which open within the horizonless worlds of Akawie and Rose; Ernst's dense, primordial landscapes anticipate the textural profusions of Martin and Hyde, and the floating inscrutability of Magritte's everyday images in impossible situations is re-captured in the metaphysical whimsy of McReynold's and Taylor's hybrid landscapes.

Like both the Surrealists and these visionaries of the 1970's, the Pre-Raphaelites in late Victorian London created their own brotherhood, consciously working against the grain of their artistic contemporaries. The Pre-Raphaelites turned to the inspirational subject matter of late medieval painting before the time of Raphael, as if the High Renaissance had never existed. They combined a realism of observed detail with a highly spiritualized subjectivism.

In a similar fashion, these seven painters have found their own native heritage in an earlier tradition, bypassing three-quarters of a century of acknowledged innovation in modern art. Fully a decade before the official self-congratulations of the Bicentennial, they had already discovered their national ancestry in the nineteenth century American landscape of the sublime, in the work of painters like Thomas Cole, Alfred Bierstadt, Frederick Church, and Thomas Moran.

The art of Joseph Parker, with its classical composition of landscape elements, and its retention of the graduations of linear and atmospheric perspective, is the closest of the seven, in formals terms, to the traditions of nineteenth century landscape painting. The panoramas of Bill Martin and Gage Taylor are likewise missing links in a native tradition that has gazed upon nature in all its prodigality, and known its awesome epiphanies first-hand.

It is this immediate experience of the sentiment movement of the forces of nature, that takes one back in historic and non-historic time, to the seared and straining cosmological visions of the British mystic poet and artist William Blake, and to the primordial stirrings of the abiding mysteries of life and creation. Blake, who lived, worked, and proselytized at the end of the Age of Reason, and at the dawn of the Romantic era, is the spiritual father of these seven artists of the 1970's, the mentor of their non-restrictive vision of experience without the loss of innocence.

The roots of Cliff McReynold's art merit a special consideration, so redolent are they of another past tradition in landscape painting, at yet a further historical remove. McReynolds is very much an heir to the Northern European conventions of painting. It began with the pearly, light-crossing surfaces of Jan Van Eyck's depictions of transcendent materiality. And surely there is something of Hieronymous Bosch in *Landscape with Hand Grenade* (Plate 18), but with none of Bosch's threatening implications. The grenade rests innocently and with utter aplomb in this pastoral new Eden like the Parthenon, a mute relic from an earlier age of man.

To the Danube painters of the early 1500's, the fusion of man with nature was a perceived feeling. This fusion and its fantastic fictions sweep across the vast spaces of *The Arrival* (Plate 40). To those who know historical painting, McReynold's work inevitably calls to mind the magnificent *Battle of Alexander,* by the Danube painter Albrecht Altdorfer. In each, an obscurely divined battle is being fought in an engulfing landscape. What matters most is not the em-battled, flagellating history of men and events, but rather the single, pulsating beat of nature's corpuscles — man is only another more-or-less excited molecule in the cosmological organism.

Even at its most hectic moments, when the earth and sky are swarming with tiny figures, one finds in McReynolds' work the cool light and shimmering haze of an essentially European experience of landscape, rather than the sharp clarities and burning suns of the New World frontiers.

Nature is a temple, where living columns
Sometimes issue co-mingled utterances.
— Baudelaire, *"Correspondences,"* 1857

Imagine a time: history. Imagine a place: history. Not written by scribes in the lofty halls of the Academy, where marble columns recede in rational progression. Rather, a history that embraces its own multiplicity, its perpetual impermanence. A network of coordinates whose positions have not been fixed and plotted in ascending and descending scales, but move like excited molecules, seemingly random in their inspiration, but definitively interdependent.

The fan of art history is opened, in a full 360-degree circle. It is no longer a question of the evolution of schools and styles, but of the ever-expanding potential for the varieties of creative experience and its expression. A question, not of the inevitability of history, but of its possibilities.

From the holy grove where the temple pillars are as alive and eloquent as nature and its celebrants, seven painters.

And finally, it is not so much a question of accumulated objects, but of whether or not there will be museums to signify them. In this sense, and in particular for these seven painters, the world has very much become their own museum. Their paintings are carefully, conscientiously reproduced as posters, as well as here in this book, to live and circulate among us.

Walter Hopps

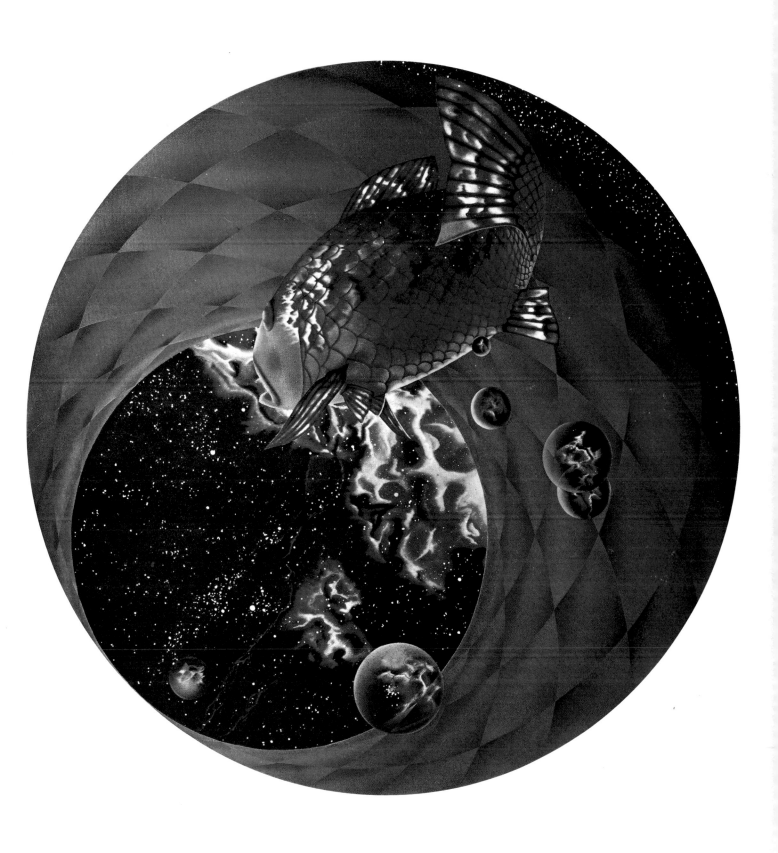

1) LIGHT, *by Sheila Rose*

1971 acrylic on canvas
40" diameter

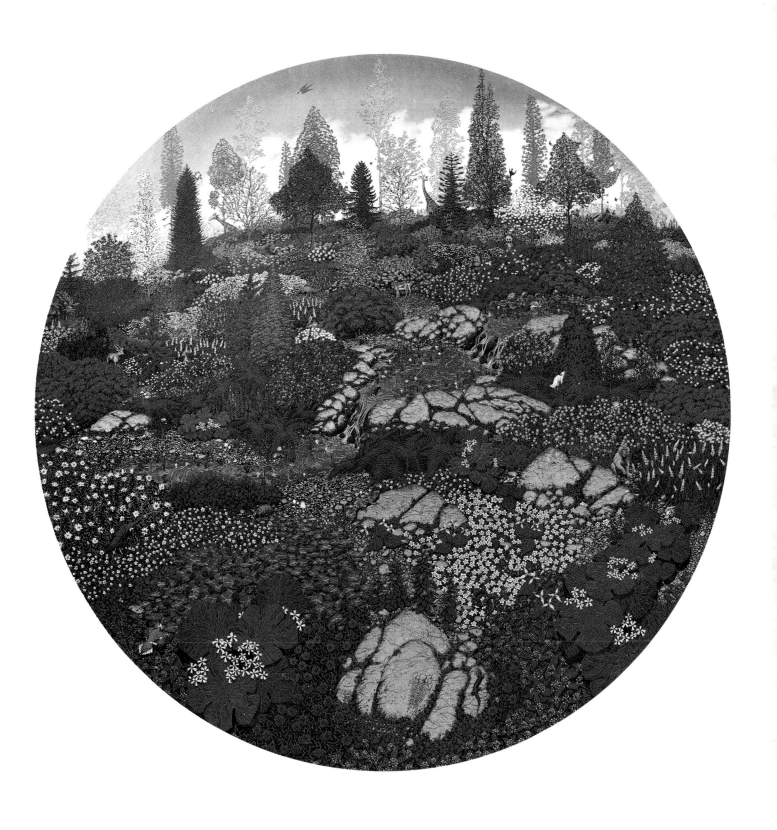

2) GARDEN OF LIFE, *by Bill Martin*

1969 oil on canvas (convex)
48" diameter

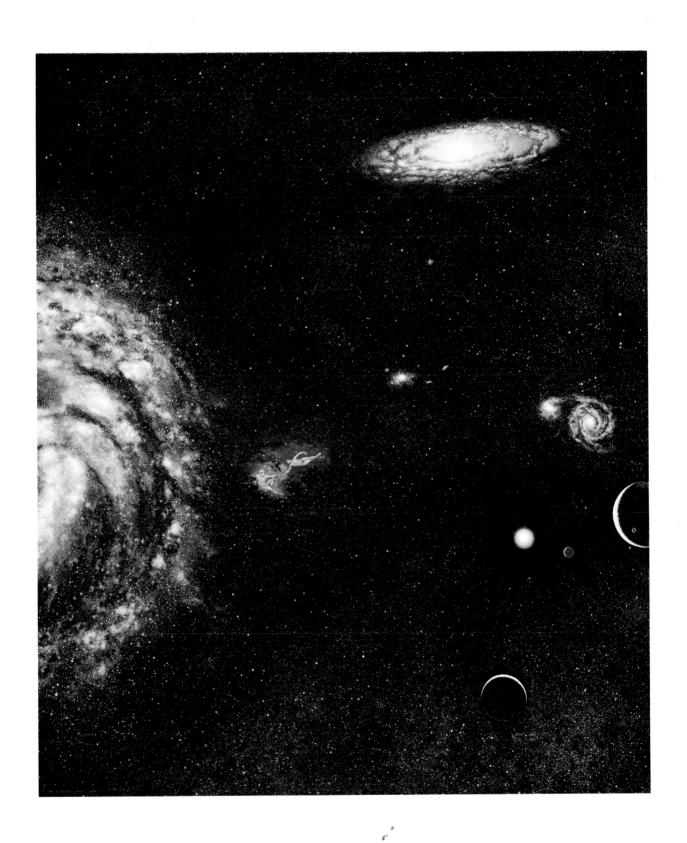

3) THE CREATION (WITH NATURAL PHENOMENA)
by Cliff McReynolds

1971 oil on masonite
32"x40"

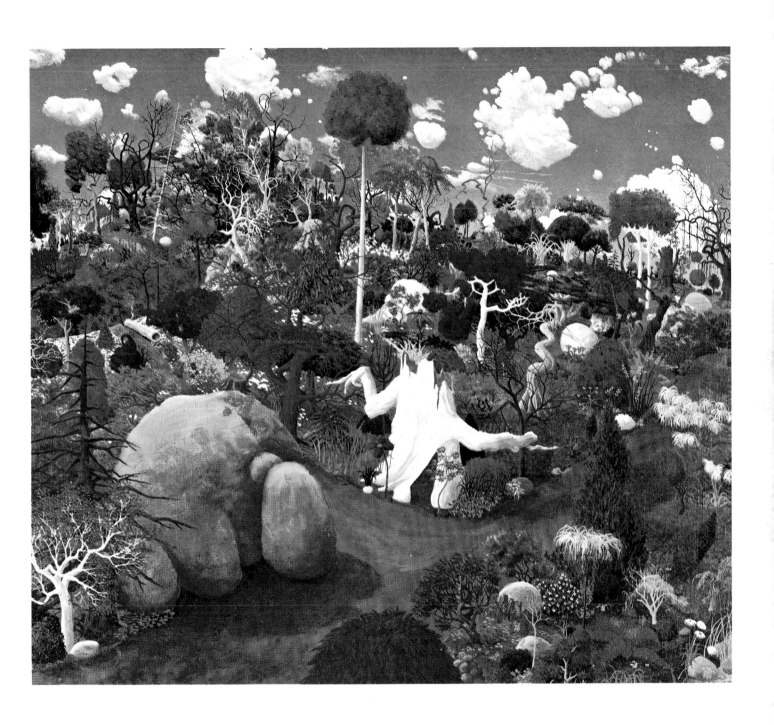

4) MESCALINE WOODS, *by Gage Taylor*

1969 oil on canvas
24"x36"

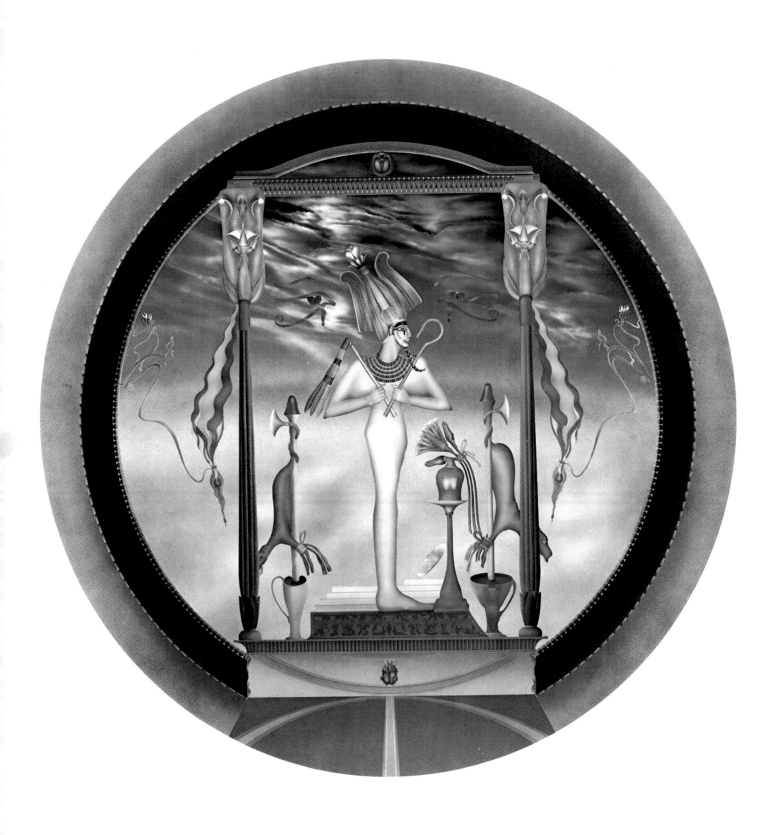

5) OSIRIS, *by Thomas Akawie*

1972 acrylic on masonite
36" diameter

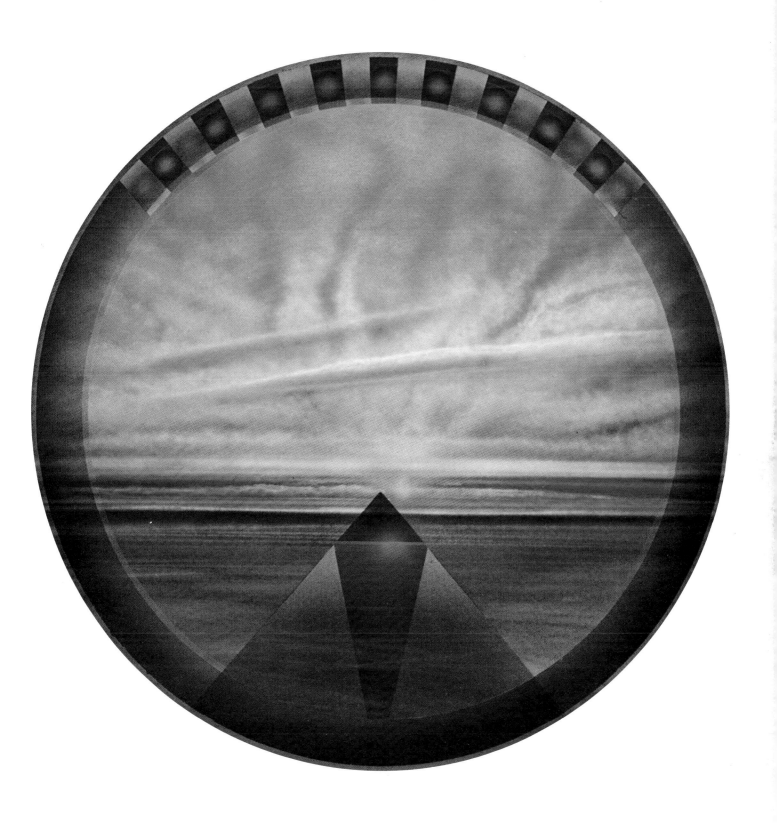

6) PYRAMID SUNSET, *by Thomas Akawie*

1974 acrylic on masonite
10" diameter

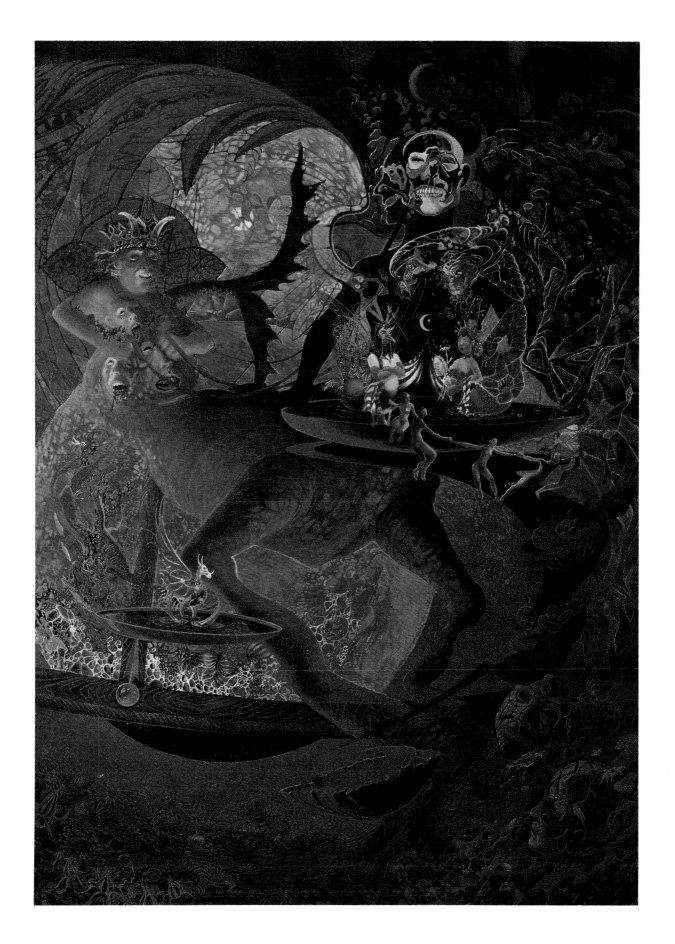

7) UNTITLED, *by Nick Hyde*

1970 oil on canvas
48"x70"

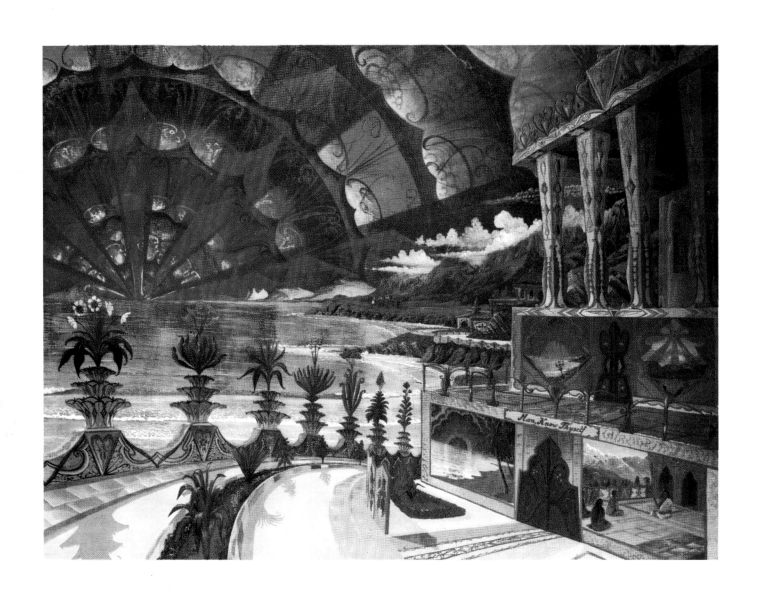

8) DAWN OF THE AQUARIAN AGE
by Joseph Parker

1968 oil on canvas
44"x60"

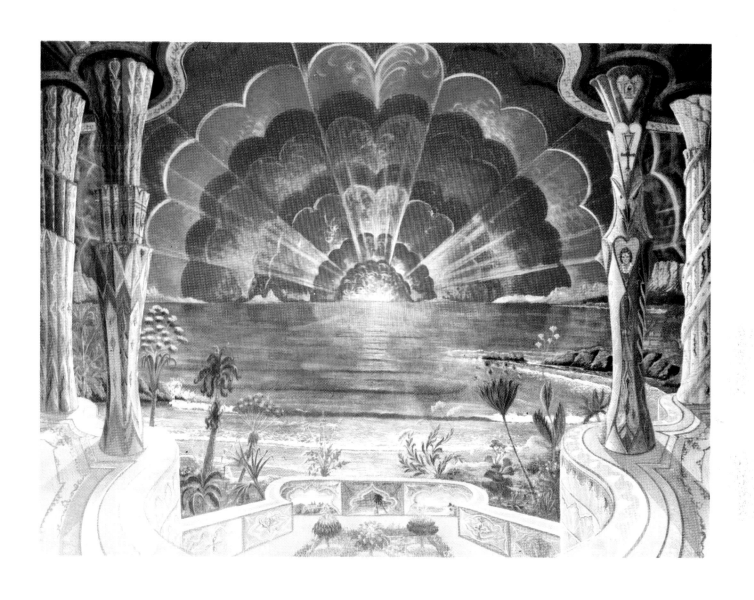

9) RISE OF THE SPIRITUAL SUN
by Joseph Parker

1968 oil on canvas
44"x60"

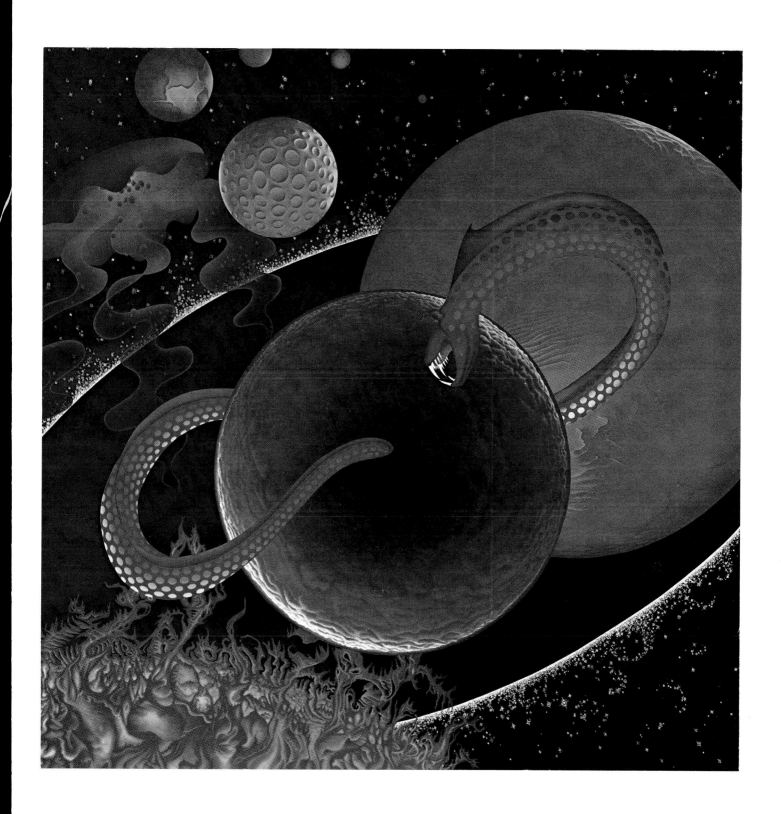

10) STARS, *by Shelia Rose*

1973 acrylic on masonite
36"x36"

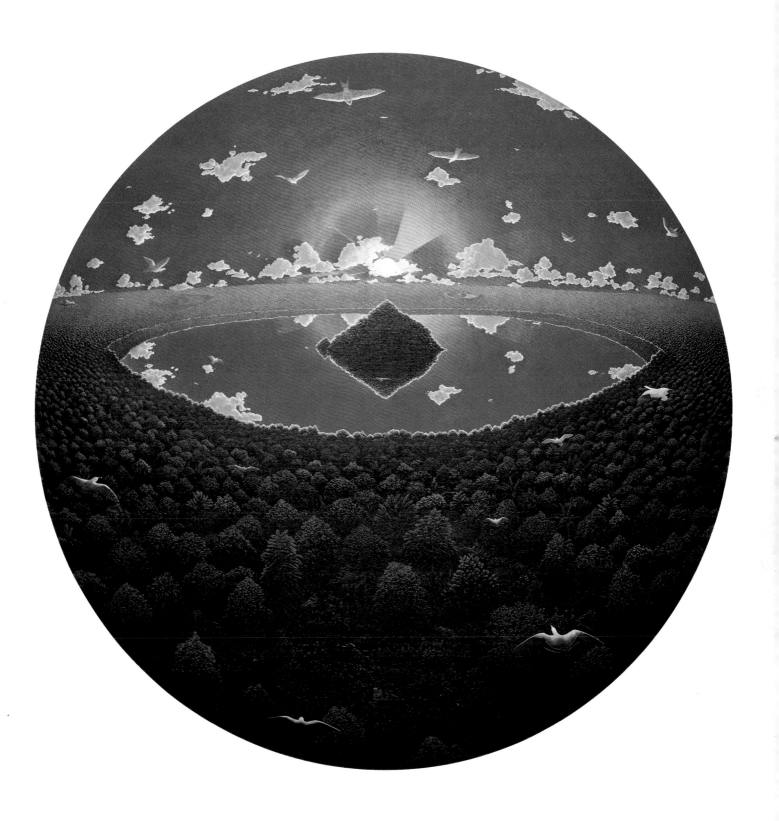

11) CRATER, *by Bill Martin*

1970 oil on canvas (convex)
48"diameter

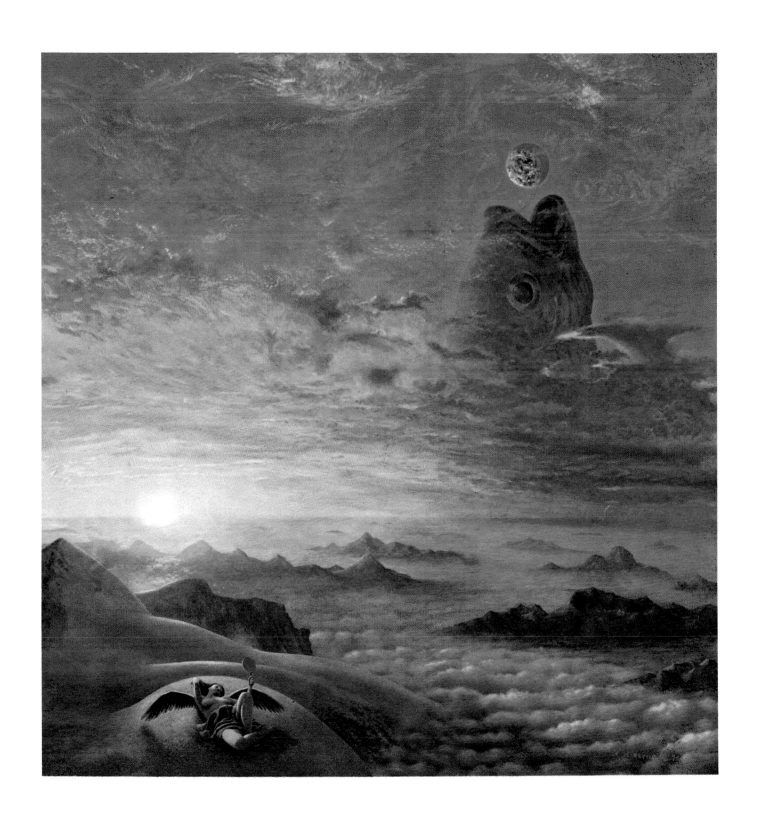

12) SOON, *by Cliff McReynolds*

1972 oil on masonite
26"x26"

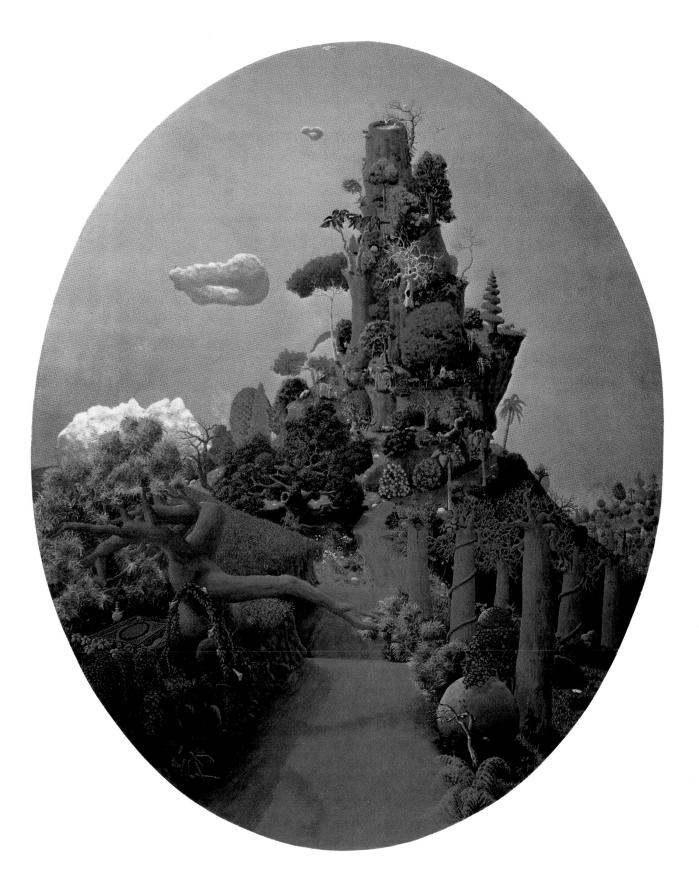

13) THE ROAD, *by Gage Taylor*

1970 oil on canvas
48"x60"

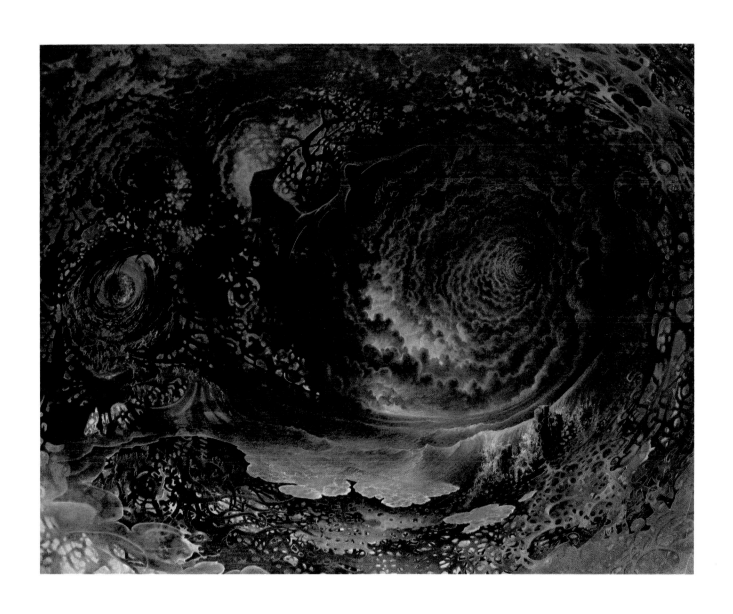

14) UNTITLED, *by Nick Hyde*

1970 oil on canvas
54"x66"

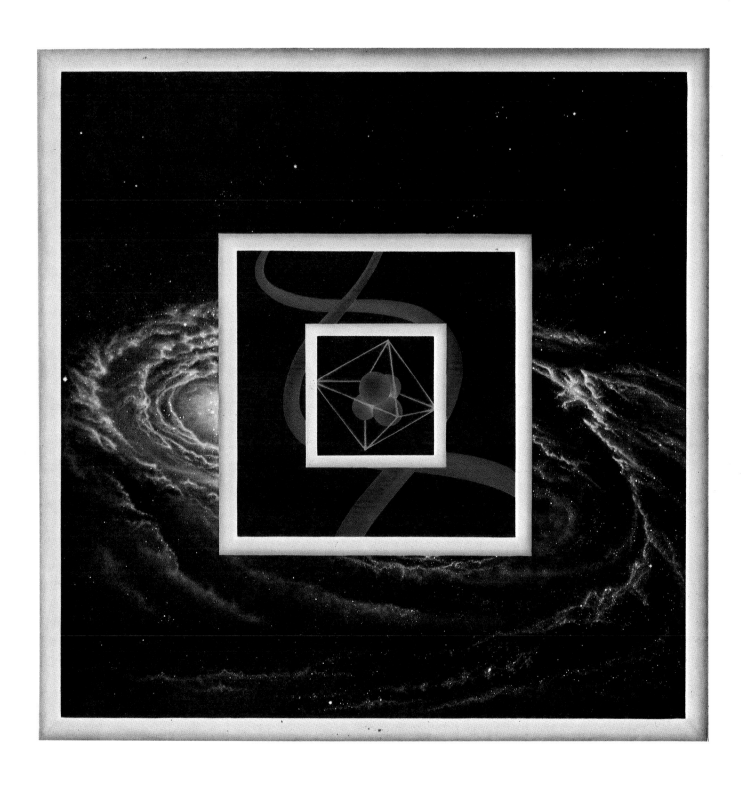

15) COSMIC ILLUSION, *by Sheila Rose*

1974 acrylic on masonite
15"x15"

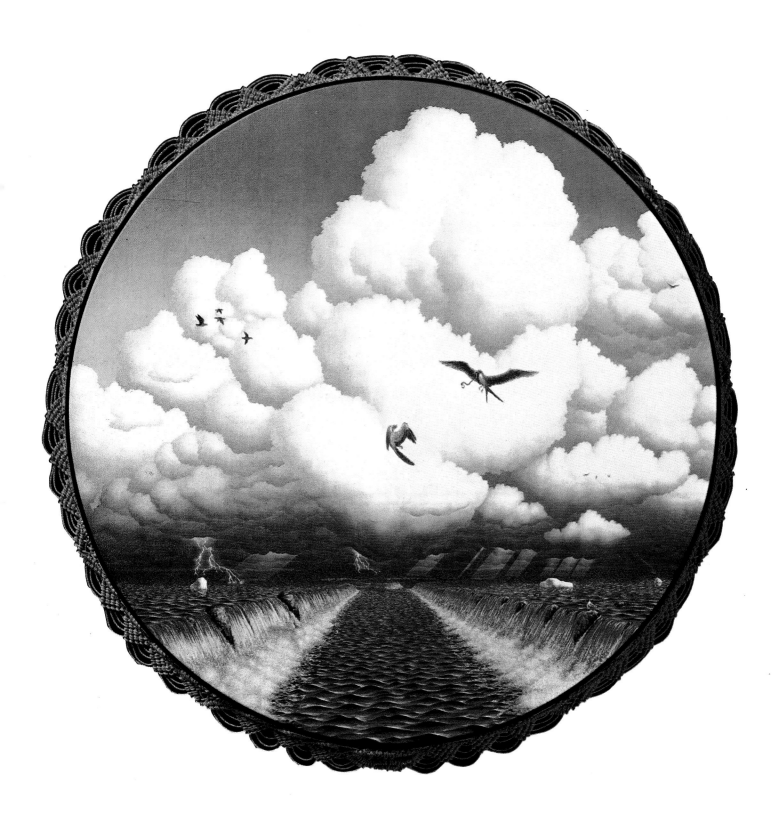

16) STORM, *by Bill Martin*

1971 oil on canvas
24" diameter

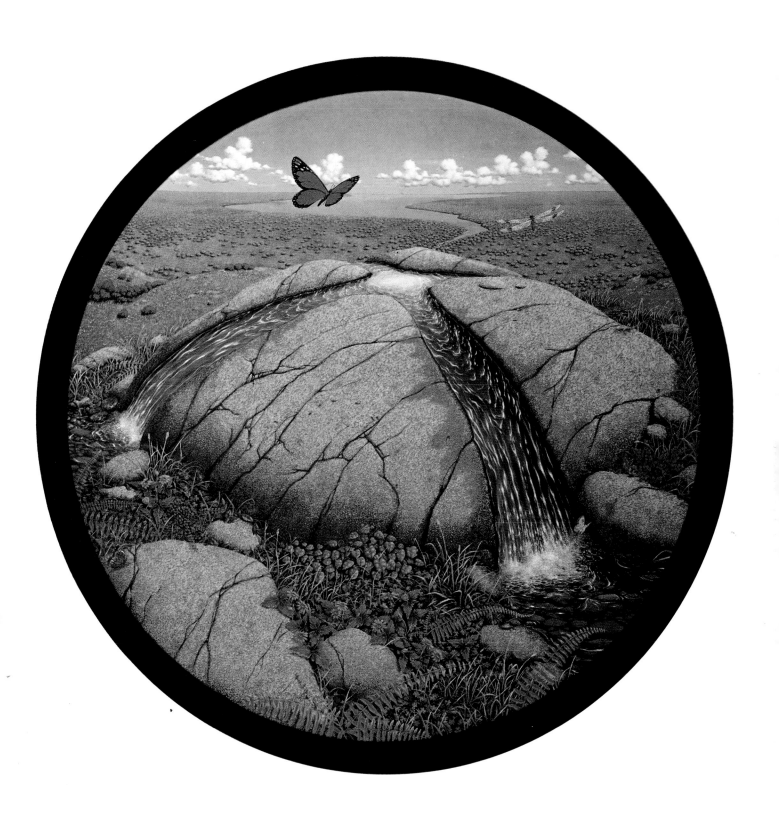

17) ROCK, *by Bill Martin*

1971 oil on canvas
24" diameter

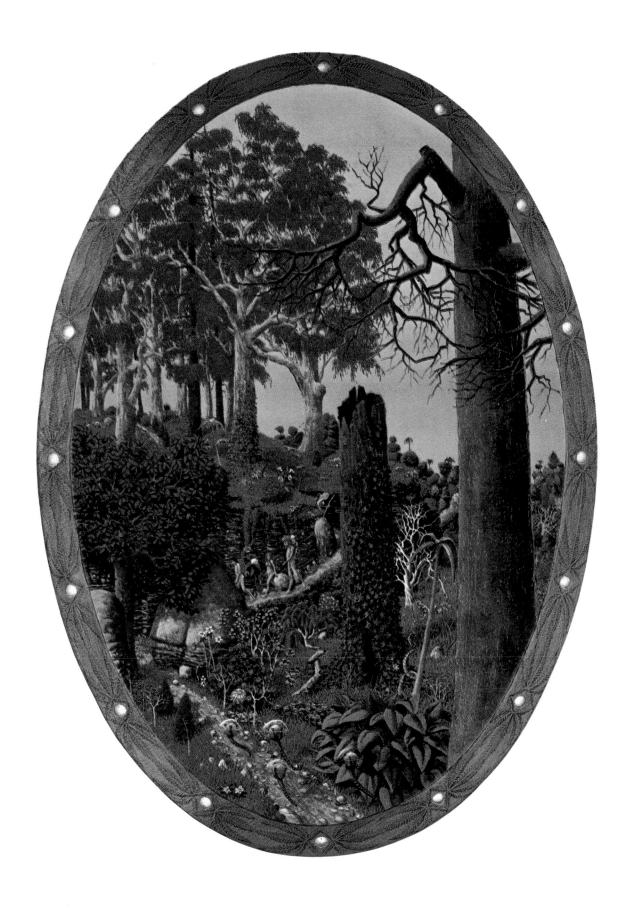

19) ENCOUNTER, *by Gage Taylor*

1971 oil on canvas
16"x22"

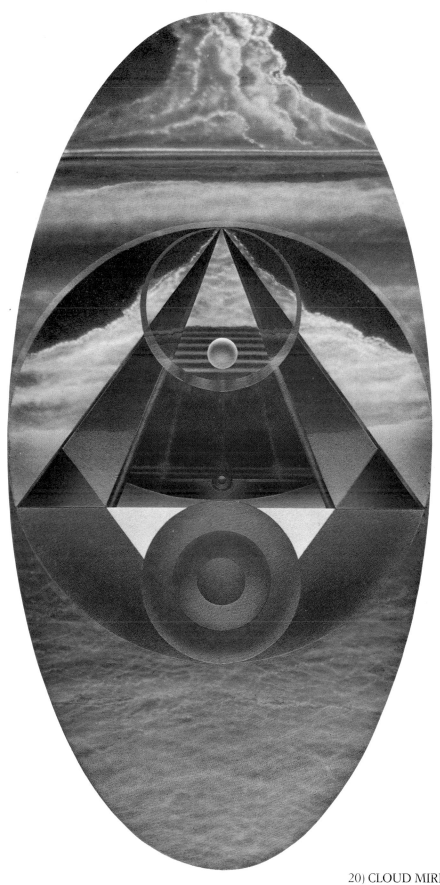

20) CLOUD MIRROR, *by Thomas Akawie*

1975 acrylic on masonite
5½ "x11"

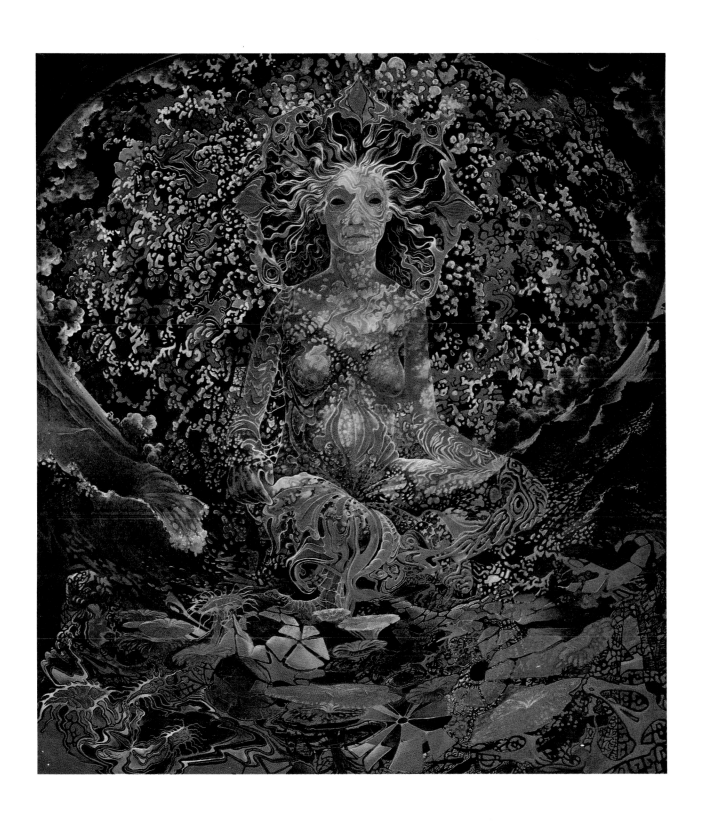

21) UNTITLED, *by Nick Hyde*

1971 oil on canvas
42"x50"

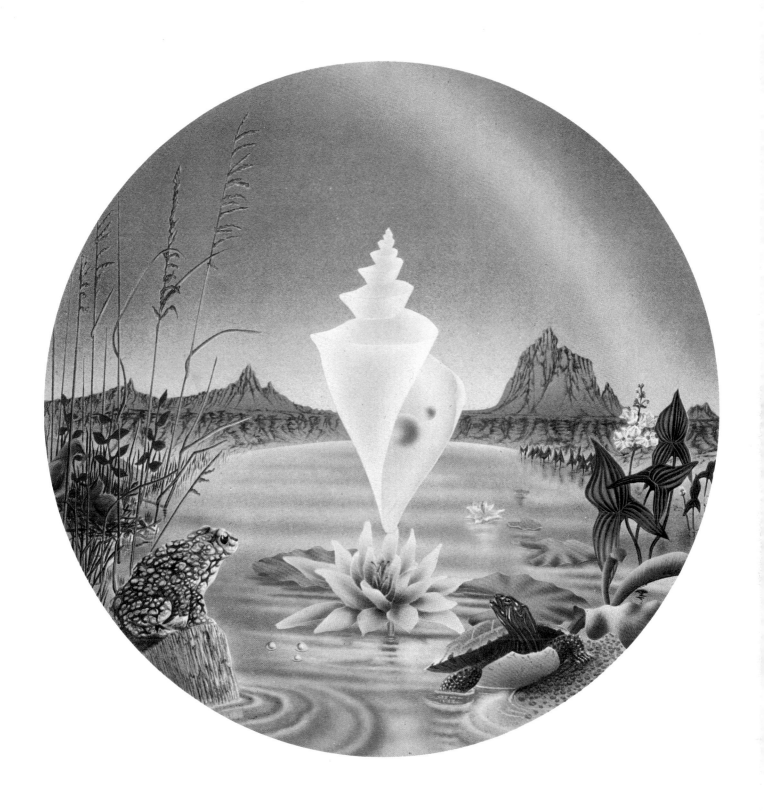

22) EGG SHELL, *by Sheila Rose*

1975 acrylic on paper
12" diameter

23) SHEILA, *by Bill Martin*

1971 oil on canvas
16" diameter

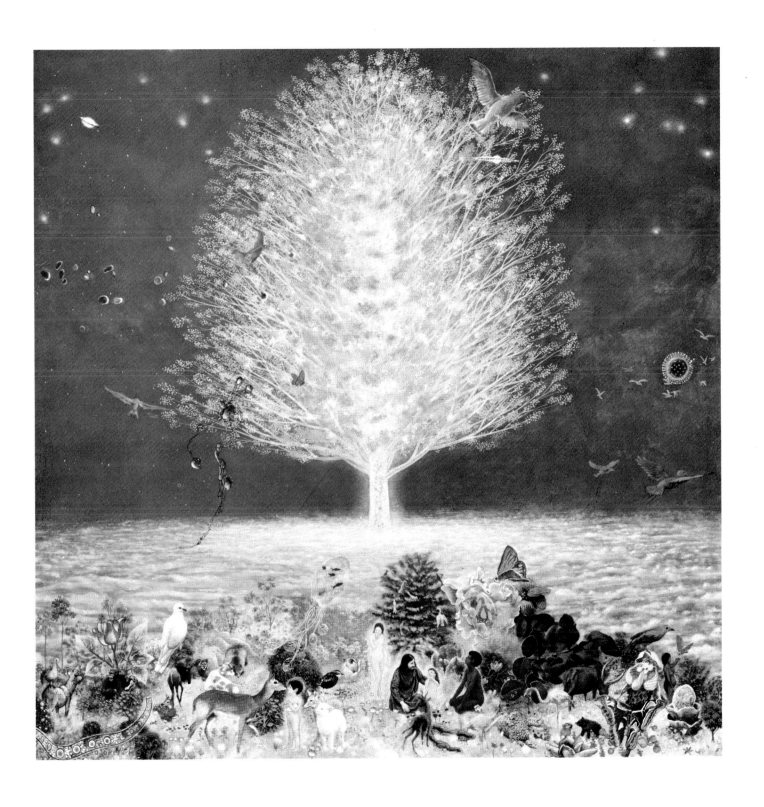

24) PORTRAIT OF HEAVEN
by Cliff McReynolds

1973 oil on masonite
17"x17"

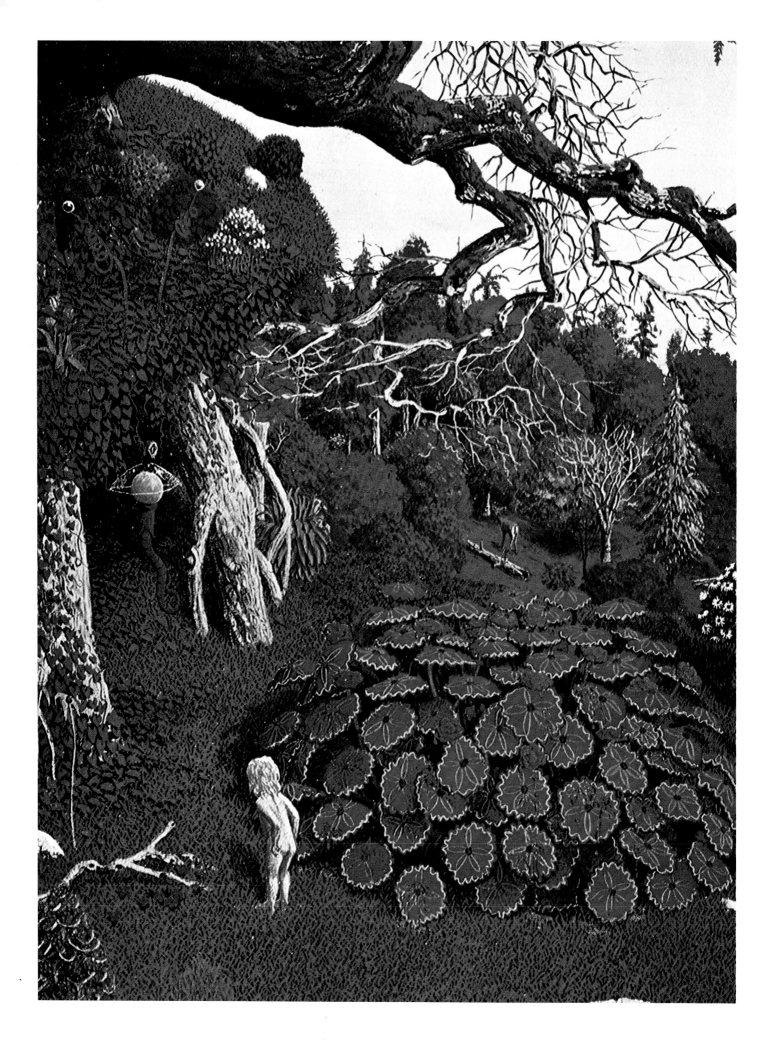

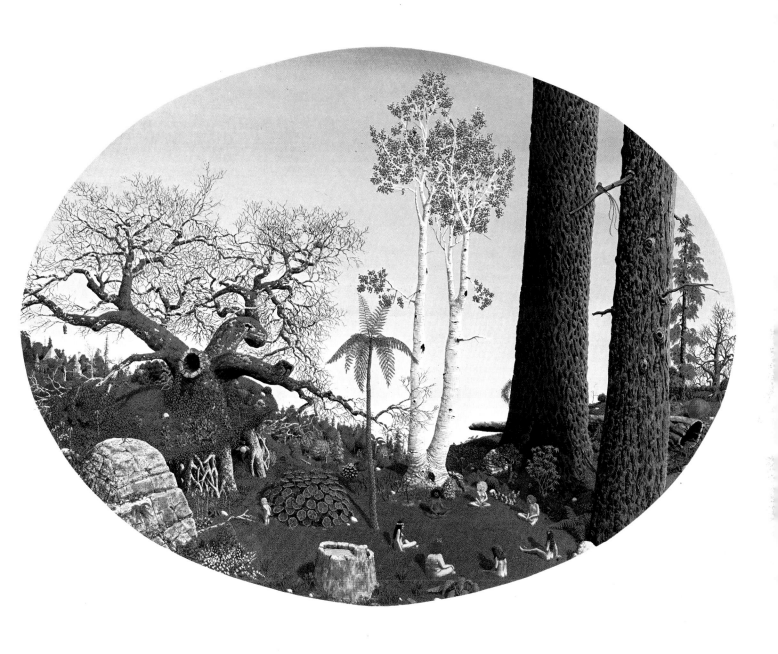

25) DETAIL, AQUARIA

26) AQUARIA, *by Gage Taylor*

1972 oil on canvas
42"x60"

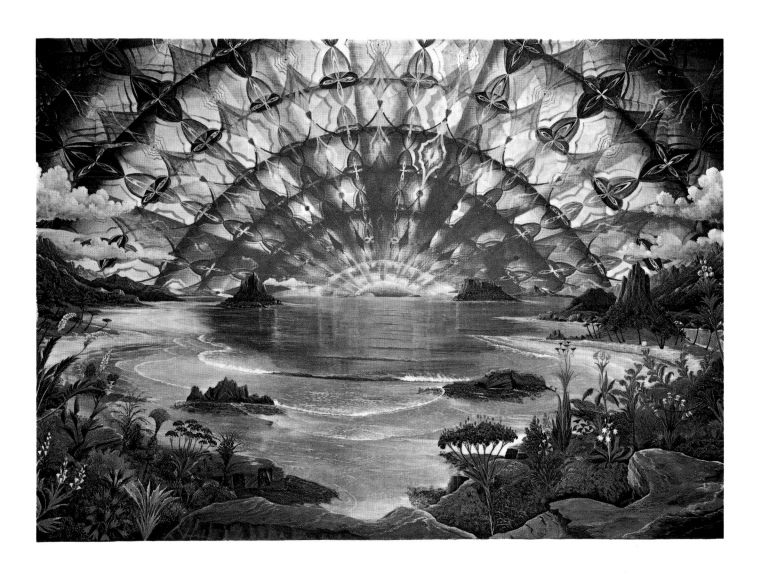

27) SUNRISE IN BLUE, *by Joseph Parker*

1969 oil on canvas
70"x100"

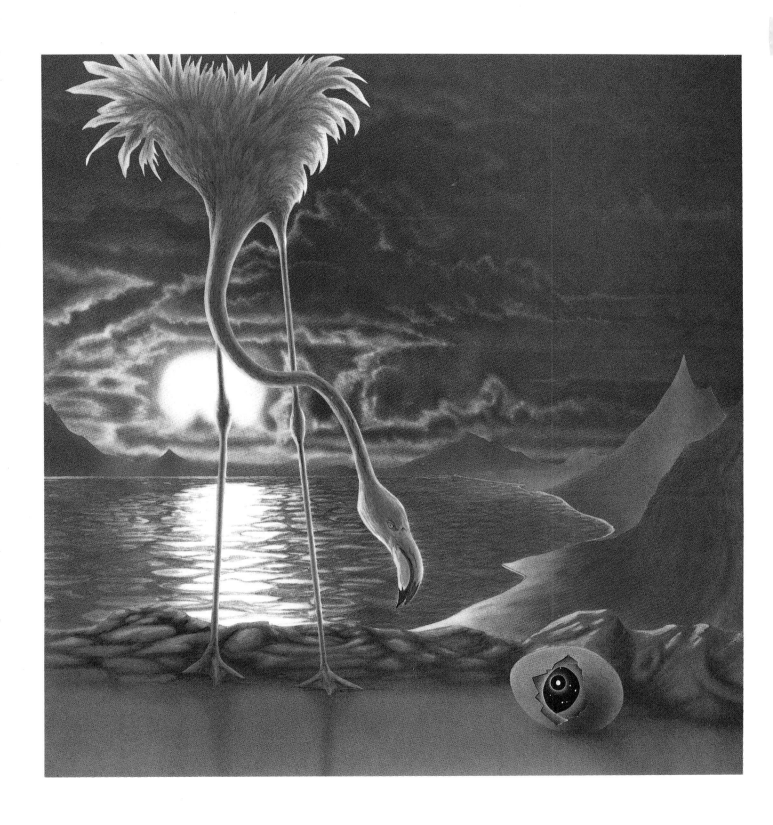

28) EGG I—COSMIC EGG
 by Sheila Rose

1976 acrylic on paper
12"x12"

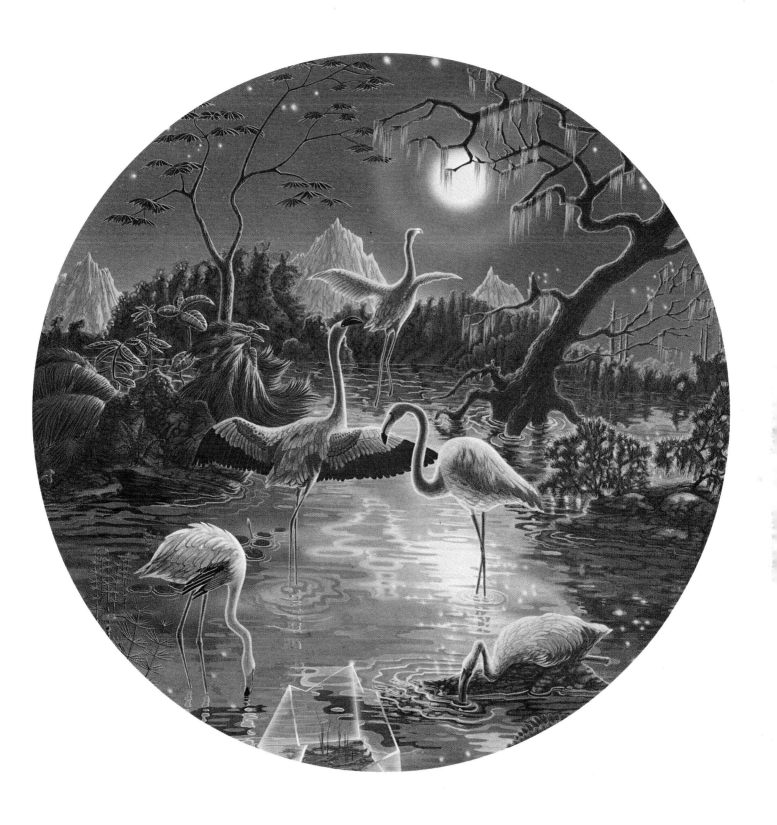

29) EGG III — RESURRECTION
by Sheila Rose

1976 acrylic and ink on rag board
16" diameter

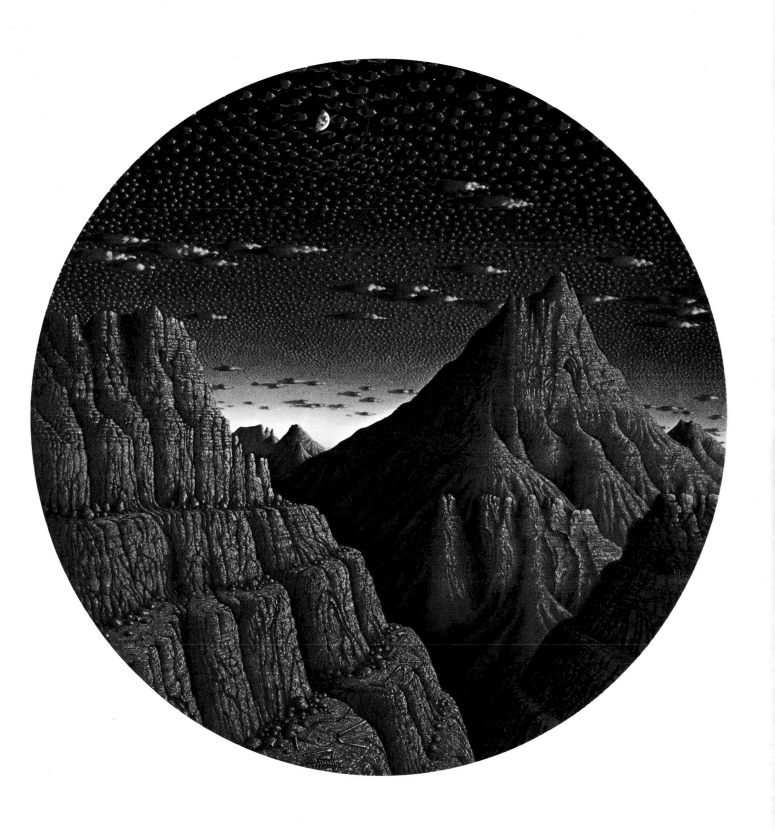

30) CANYON, *by Bill Martin*

1972 oil on canvas
32" diameter

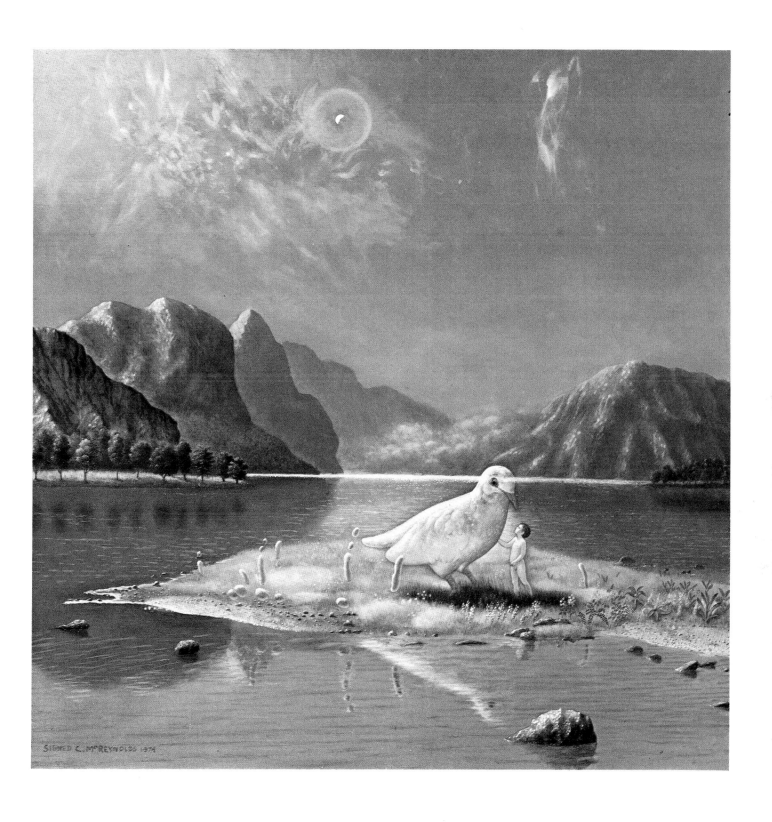

31) LANDSCAPE WITH BIRD AND BOY
by Cliff McReynolds

1974 oil on masonite
12"x12"

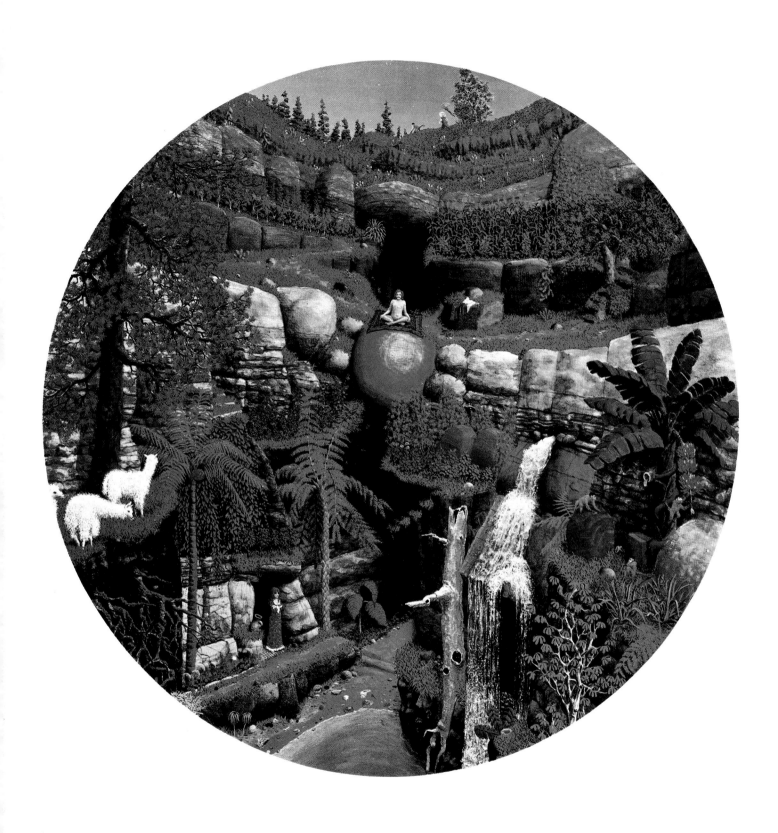

32) SOUTH AQUARIA, *by Gage Taylor*

1973 oil on canvas
27"x29"

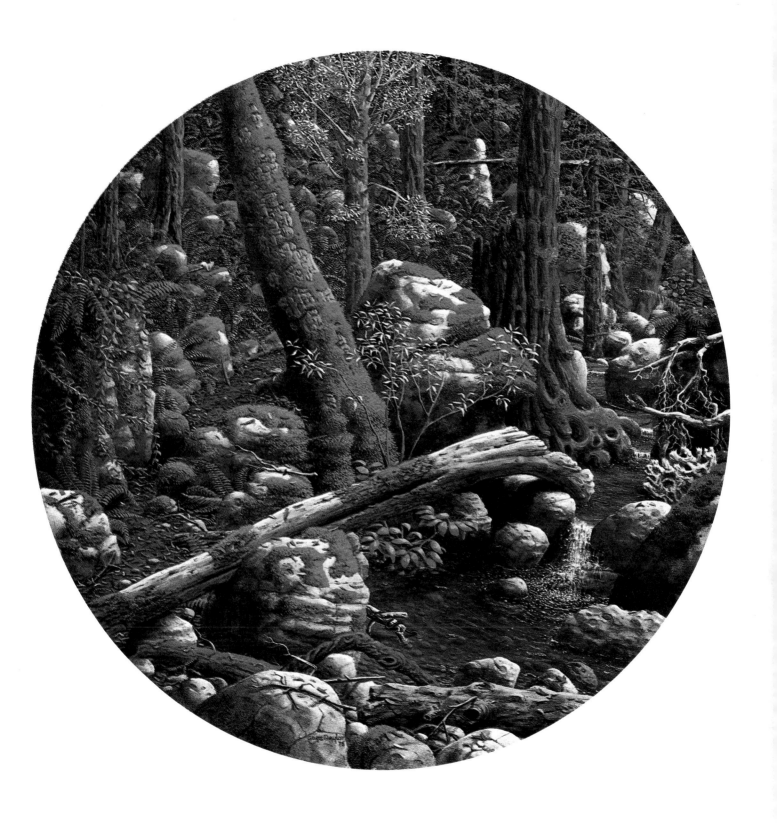

33) THE CREEK, *by Gage Taylor*

1976 oil on canvas
14" diameter

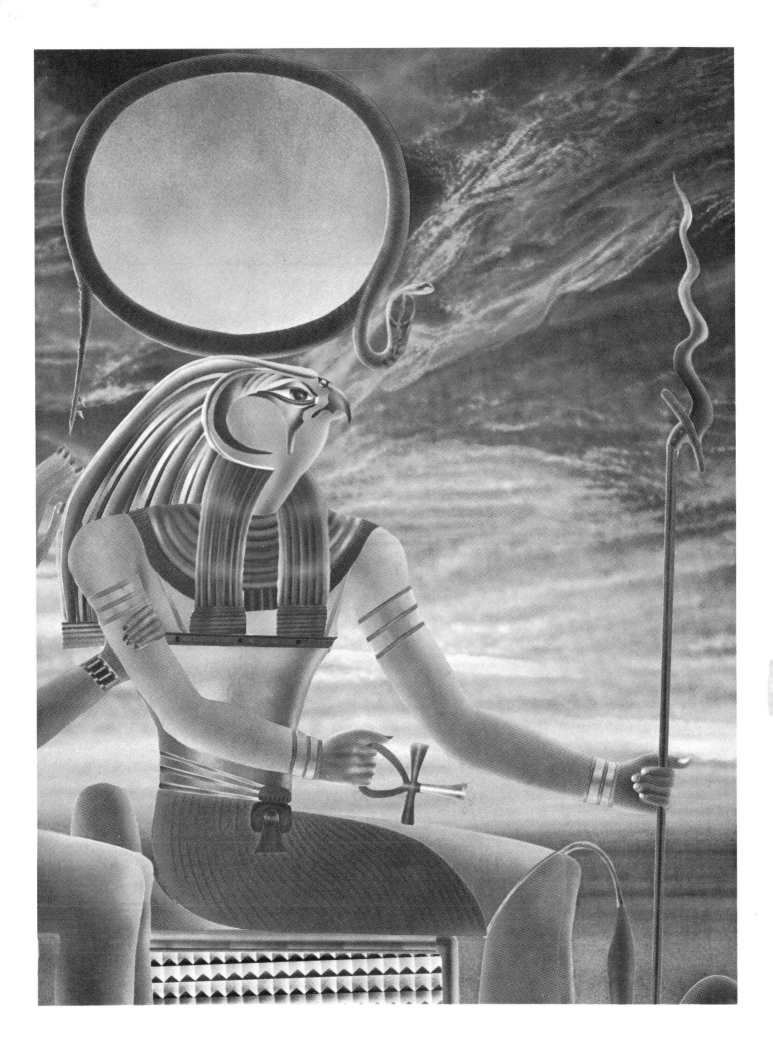

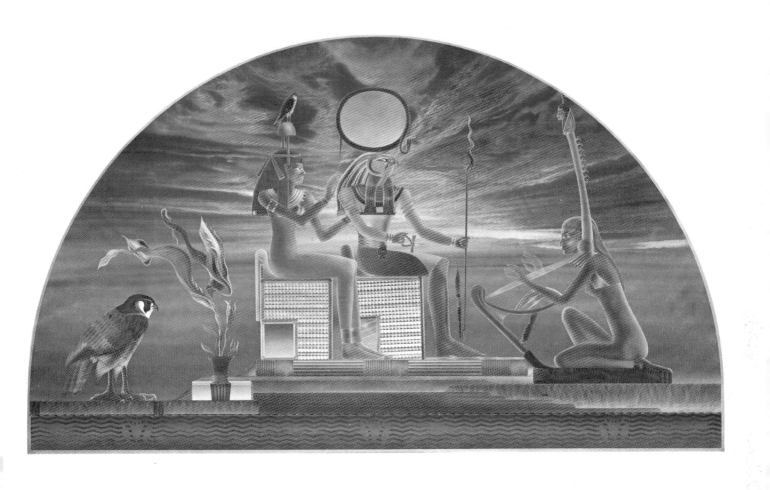

34) RA, DETAIL

35) RA, *by Thomas Akawie*

1974 acrylic on masonite
23"x40"

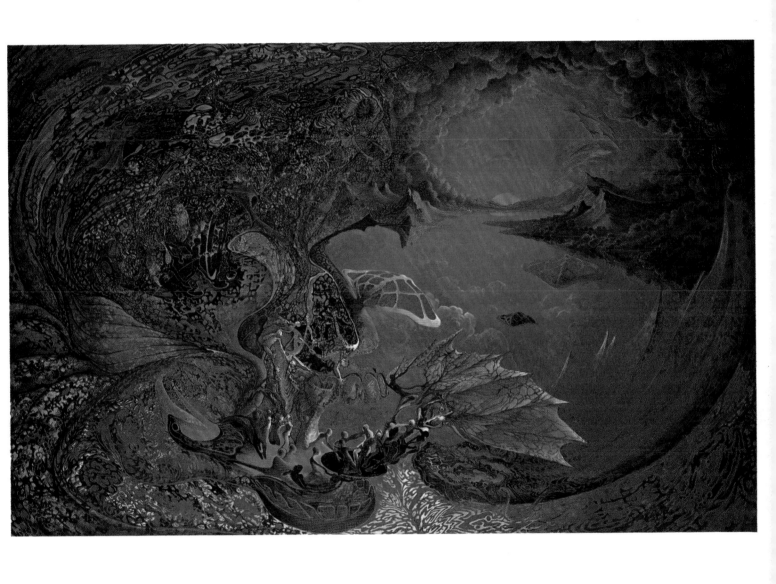

36) ESTATE OF MAN, *by Nick Hyde*

1971 oil on canvas
67"x104"

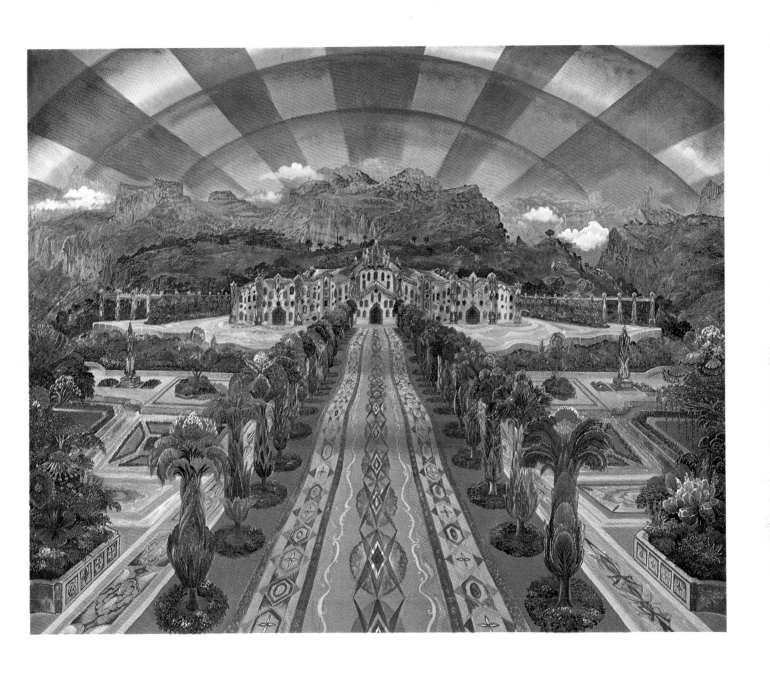

37) UNTITLED, *by Joseph Parker*

1973 oil on canvas
44"x53"

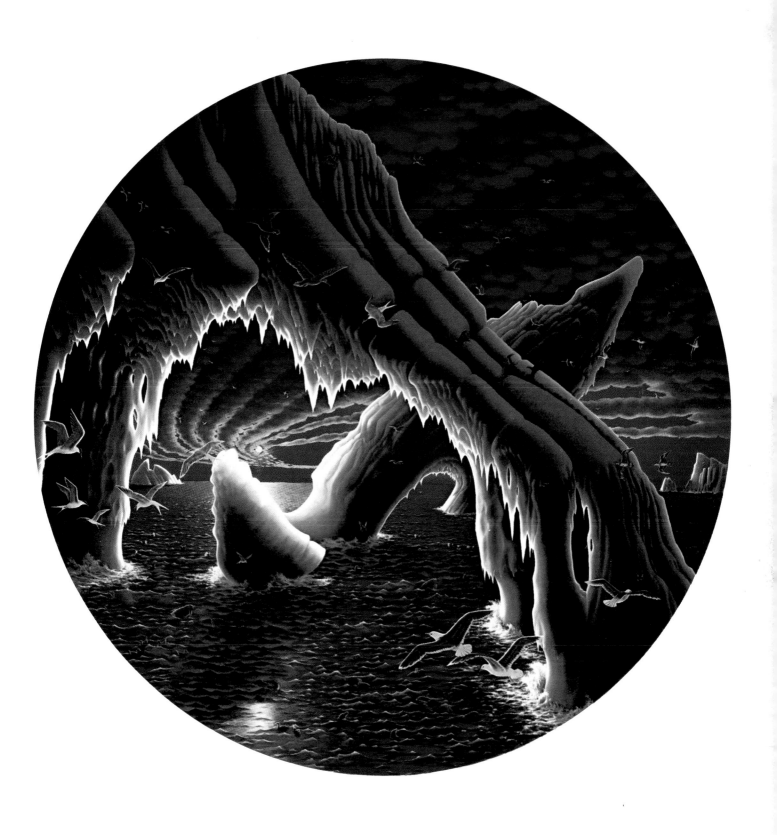

38) ICEBERG, *by Bill Martin*

1973 oil on canvas
23" diameter

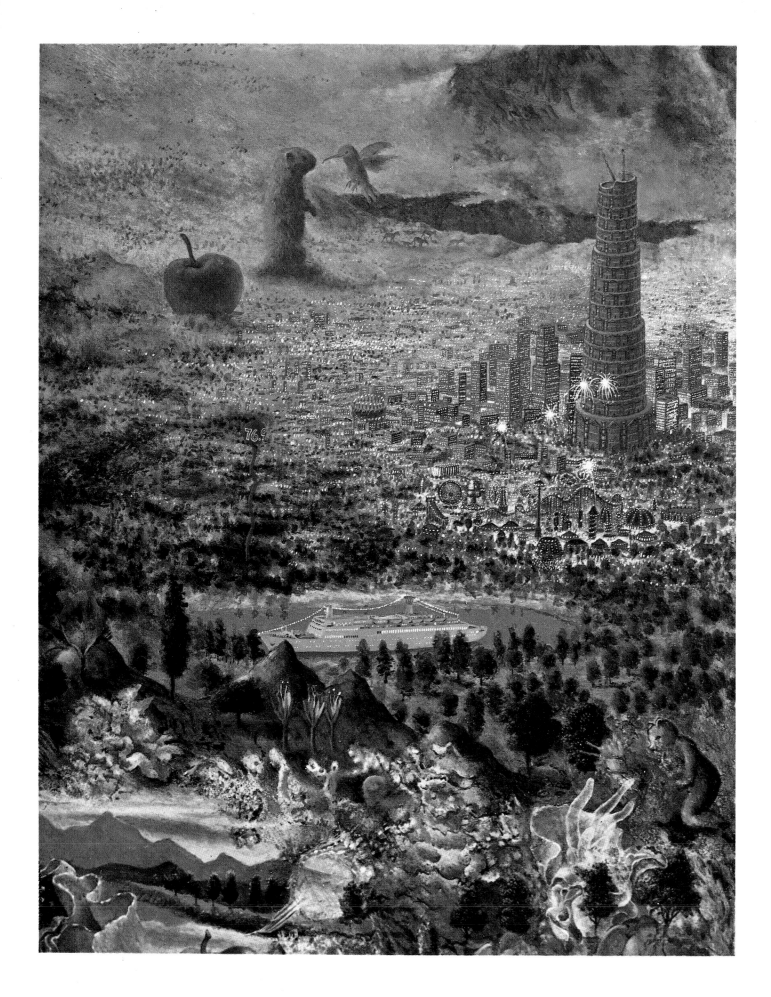

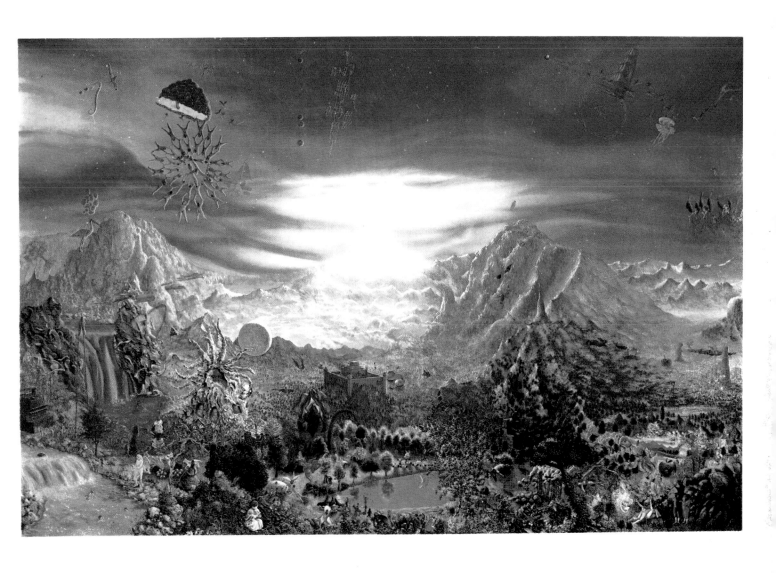

39) DETAIL, THE ARRIVAL

40) THE ARRIVAL (MATTHEW 24:24),
by Cliff McReynolds

1975 oil on masonite
40"x60"

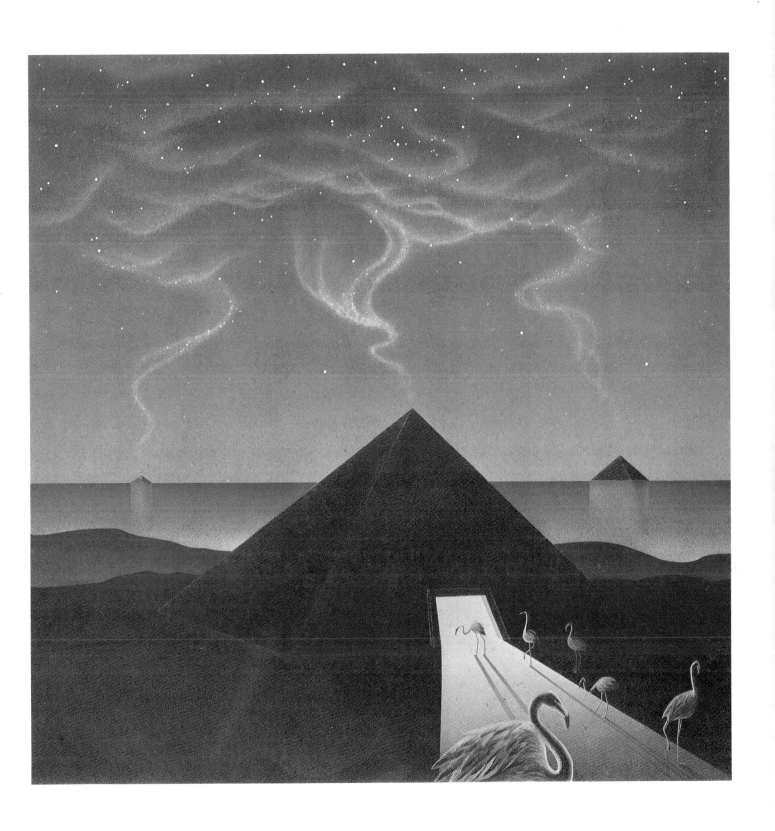

41) TRANSMIGRATION OF SOULS IN BLUE
by Sheila Rose

1975 acrylic on paper
12"x12"

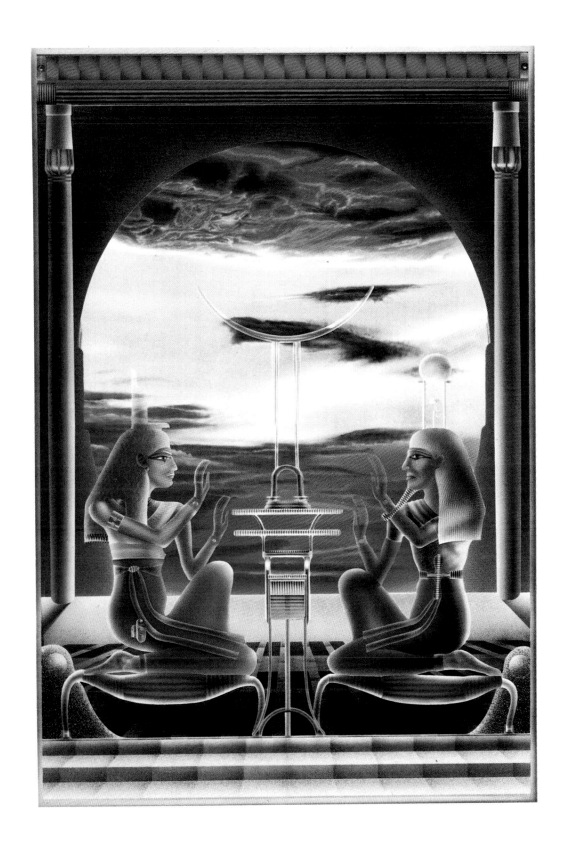

42) RA RISING, *by Thomas Akawie*

1976 acrylic on masonite
15"x22"

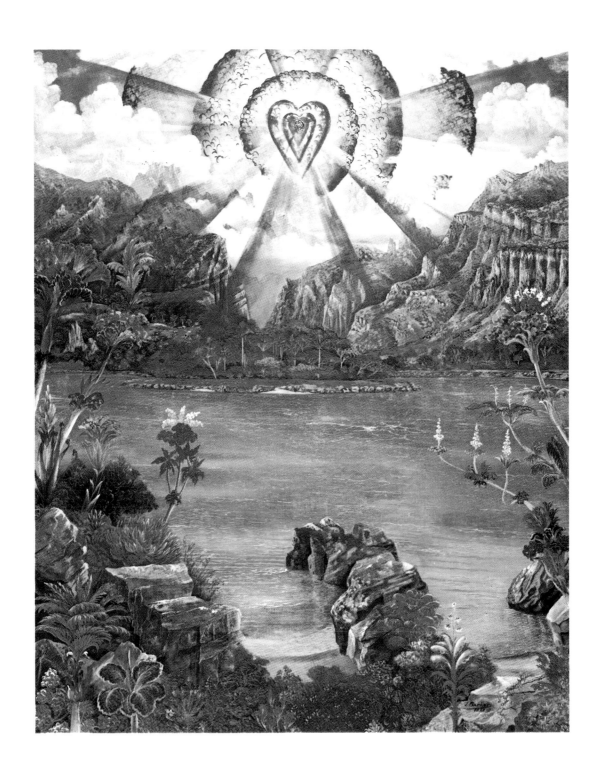

43) ANTICIPATED MOMENT
by Joseph Parker

1973 oil on canvas
43"x54"

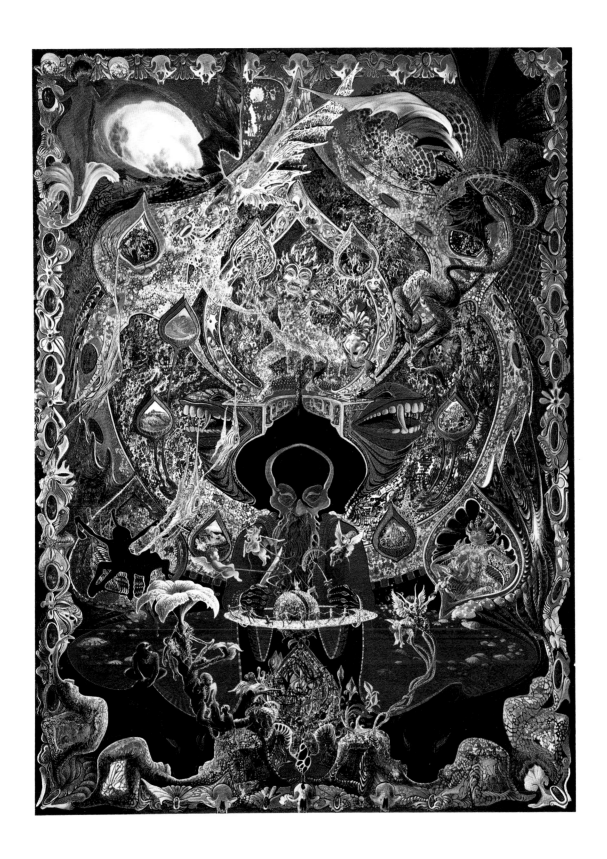

44) URP, *by Nick Hyde*

1972 oil on canvas
60"x78"

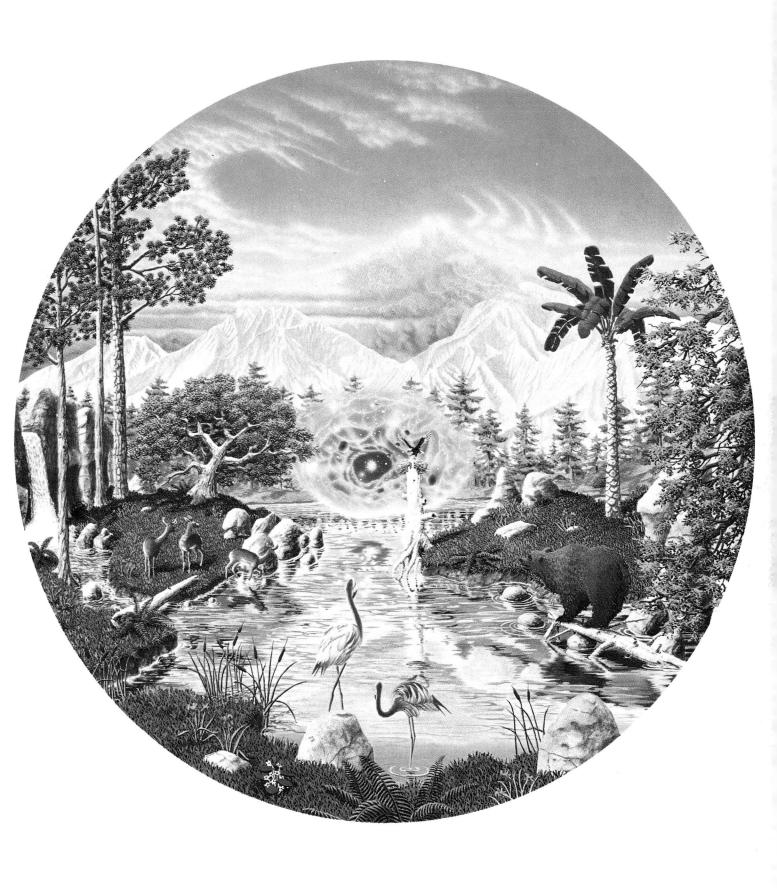

45) MANIFESTATION, *by Sheila Rose
and Gage Taylor*

*1976 acrylic and gouache on board
18" diameter*

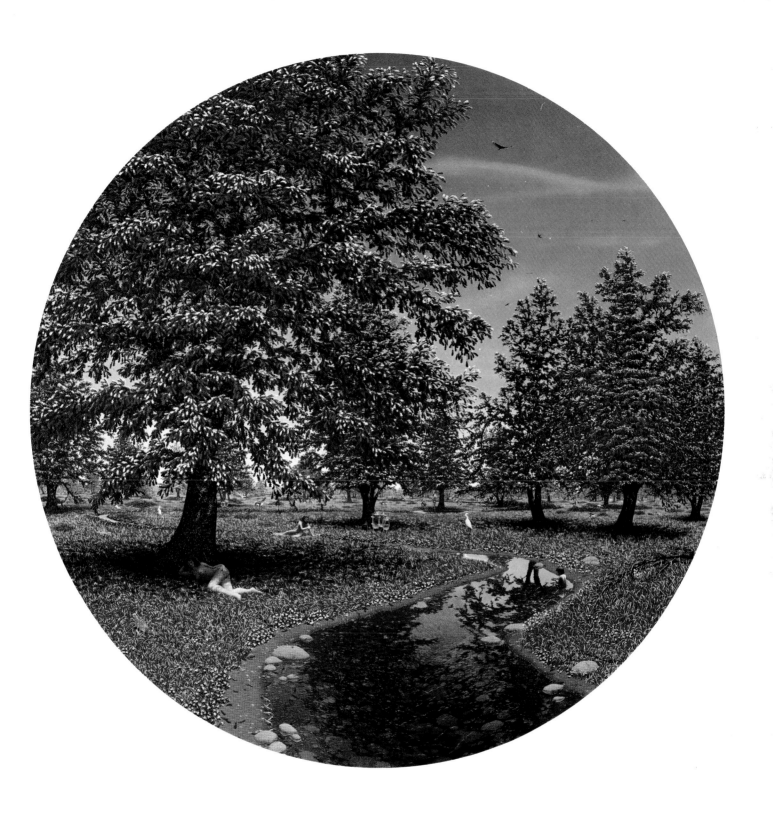

47) AUTUMN, *by Bill Martin*

1976 oil on canvas
54" diameter

46) DETAIL, AUTUMN

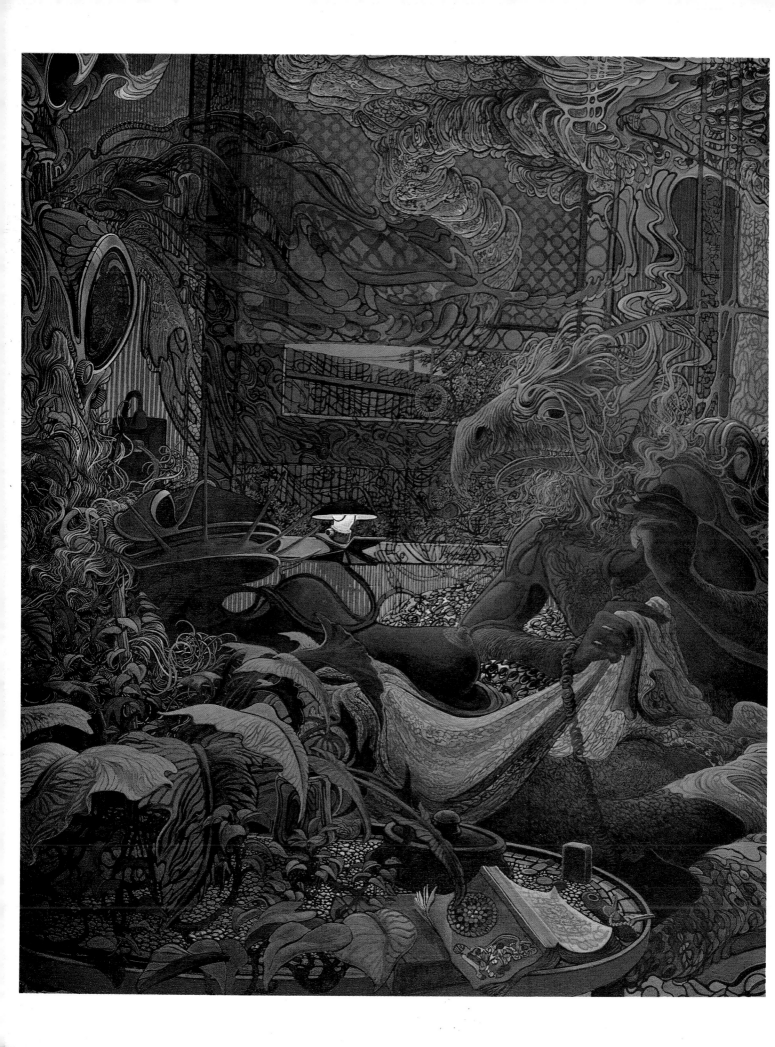

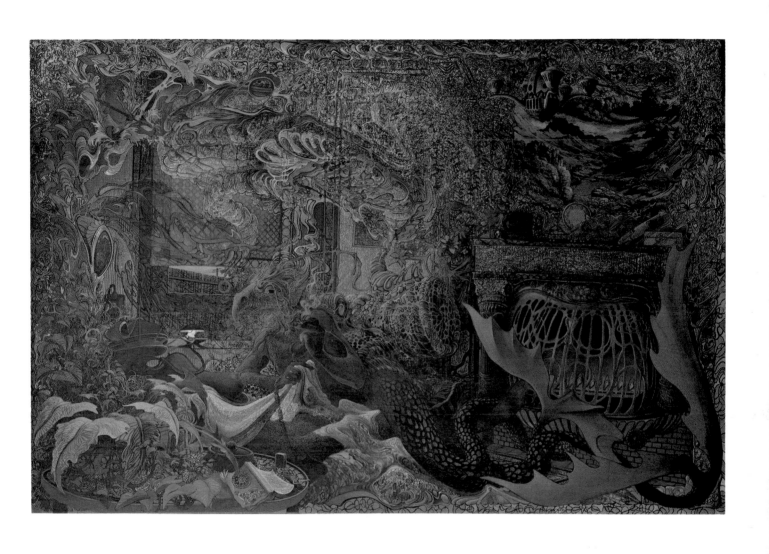

48) DETAIL, ABRAXAS

49) ABRAXAS, *by Nick Hyde*

1976 oil on canvas
54"x78"

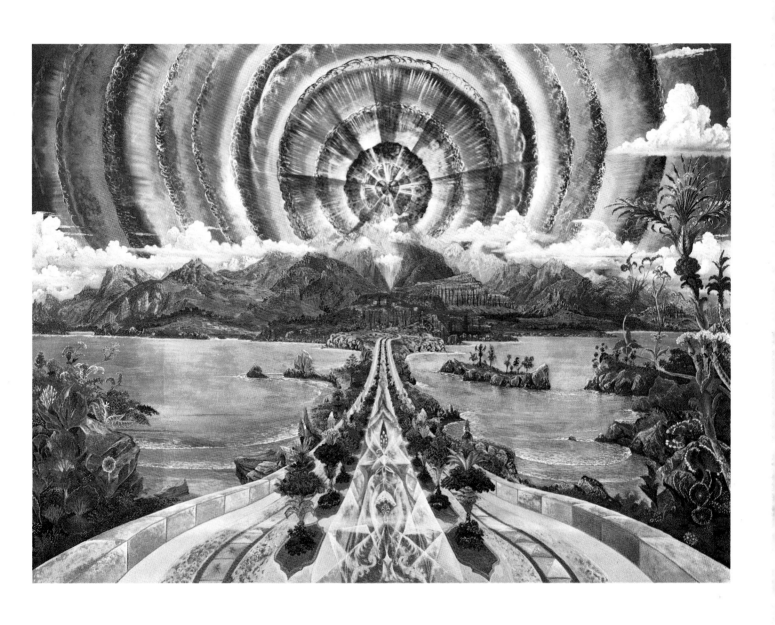

50) THE PATH, *by Joseph Parker*

1973 oil on canvas
59"x79"